Rembrandt

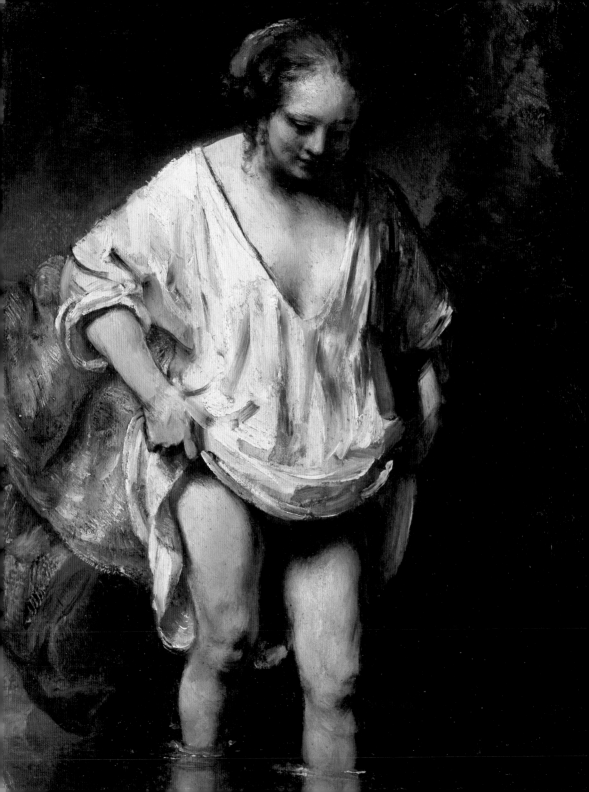

Rembrandt

Stefano Zuffi

PRESTEL
Munich · London · New York

Front cover: *Small Self-Portrait*, 1657, Kunsthistorisches Museum Vienna (detail)
Frontispiece: *A Woman Bathing in a Stream (Hendrickje Stoffels?)*, 1654, National Gallery,
London (detail), see page 107
Back cover: *Self-Portrait as a Young Man*, c. 1628, Staatliche Kunstsammlungen, Kassel (detail)

© Prestel Verlag, Munich · London · New York, 2011
© Mondadori Electa SpA, 2007 (Italian edition)

British Library Cataloguing-in Publication Data: a catalogue record for this book is
available from the British Library; Deutsche Nationalbibliothek holds a record of this
publication in the Deutsche Nationalbibliografie; detailed bibliographical data can
be found under: http://dnb.d-nb.de

The Library of Congress Number: 2011931019

Prestel Verlag, Munich
A member of Verlagsgruppe Random House GmbH

Prestel Verlag
Neumarkter Strasse 28
81673 Munich
Germany
Tel. +49(0)89 4136 0
fax +49(0)89 4136 2335
www.prestel.de

Prestel Publishing Ltd.
4 Bloomsbury Place
London WC1A 2QA
Tel. +44 (0)20 7323-5004
Fax +44 (0)20 7636-8004
www.prestel.com

Prestel Publishing
900 Broadway, Suite 603
New York, NY 10003
Tel. +1 (212) 995-2720
Fax +1 (212) 995-2733

www.prestel.com

Prestel books are available worldwide. Please contact your nearest bookseller or
one of the above addresses for information concerning your local distributor.

Editorial direction by Claudia Stäuble, assisted by Franziska Stegmann
Translated from the German by Jane Michael
Copyedited by Chris Murray
Production: Astrid Wedemeyer
Typesetting: Wolfram Söll, Munich
Cover: Sofarobotnik, Augsburg & Munich
Printing and binding: Mondadori Printing, Verona, Italy

ISBN 978-3-7913-4620-5

Contents

Introduction

The scope of Rembrandt's life extended no further than the forty-odd kilometers which separate his birthplace, Leiden, from the Dutch capital, Amsterdam: a flat landscape dominated by water and low skies. Rembrandt was the son of a miller, came from the provinces, and undertook no long journeys. And yet he became an artist who was famous and sought-after throughout Europe. The flourishing art trade in Amsterdam, which brought together a huge quantity of paintings, drawings and prints by famous artists, gave Rembrandt ample opportunity to satisfy his artistic curiosity and to follow the stylistic developments of the time.

As the most important Dutch artist, Rembrandt competed with the Flemish artists Peter Paul Rubens of Antwerp for the position of leading artist in Northern Europe. He was certainly aware of this fact and was not even afraid to have his works compared with those of the masters of the Italian Renaissance from Leonardo to Titian: like them, he signed his works with only his first name. As in the case of all great masters, his paintings moved people during his lifetime and had a lasting influence on countless artists. Rembrandt's art has lost nothing of its extraordinary fascination.

Over the centuries a wide range of characterizations and interpretations of Rembrandt's art have been provided, but no matter how apt and perceptive they may be, in view of the richness of his oeuvre, which includes painting, prints and drawing, any attempt at neat categorization is bound to fail. The closer one approaches Rembrandt, the more he seems to retreat into the distance. In spite of the countless self-portraits he left, his true face remains hidden. Perhaps the comment of the Florentine scholar and connoisseur Filippo Baldinucci can help us; in 1686 he wrote a comment about Rembrandt which seems rather strange at first sight—that he was an "excellent humorist." Perhaps this is a way to understand the Rembrandt phenomenon: his indefatigable urge to create pictures, his mania for collecting, the complications of his private life, the periods of economic success and disasters—Rembrandt as a mask, an actor playing a role, always in search of identity. Even in his early works he speaks to viewers directly, draws them in and so lets them participate in the actions

and emotions of his paintings. In his self-portraits, Rembrandt adopts a wide variety of roles and costumes over the course of the years, from the ragged beggar to the youthful daredevil or Renaissance nobleman, from the somewhat self-satisfied middle-class burgher to the painter prince. Appearances and transformations on the stage of art, but always linked to an amazement at the power exercised by painting—by the challenge of the empty canvas and a fascination with the materiality of paint, which he modeled on the canvas using a well-loaded brush and sometimes even his fingers.

Only in the last years of his life, driven to ruin by his creditors and isolated as an artist, did Rembrandt abandon this "theater" and show himself as he really was: an old man, outmoded as an artist but still, despite a series of tragedies, radiating his love for life and a profound sense of the seriousness and dignity of painting. During his entire creative life Rembrandt never stopped experimenting and seeking new ways to paint. He repeatedly resisted the temptation to pander to the current preference for light, "clean" painting. In the last decade of his life, in many respects a very difficult period, he found himself subjected to the criticism of art experts for his heavy, "impure" painting technique, which some claimed to see as the expression of a morally degenerate man. Two of the few comments by the artist to have been handed down suddenly cast light on Rembrandt's inner development in the face of his public. Although as a young man he subscribed to the highly conventional motto "A pious man values honor more than wealth," he supposedly said of himself at the end of his life: "For the sake of my soul, I do not strive for glory but for freedom!"

Especially in his impressive late works, it is in this spirit of freedom that Rembrandt abandoned the boundaries of art and created a timeless witness of touching humanity.

Stefano Zuffi

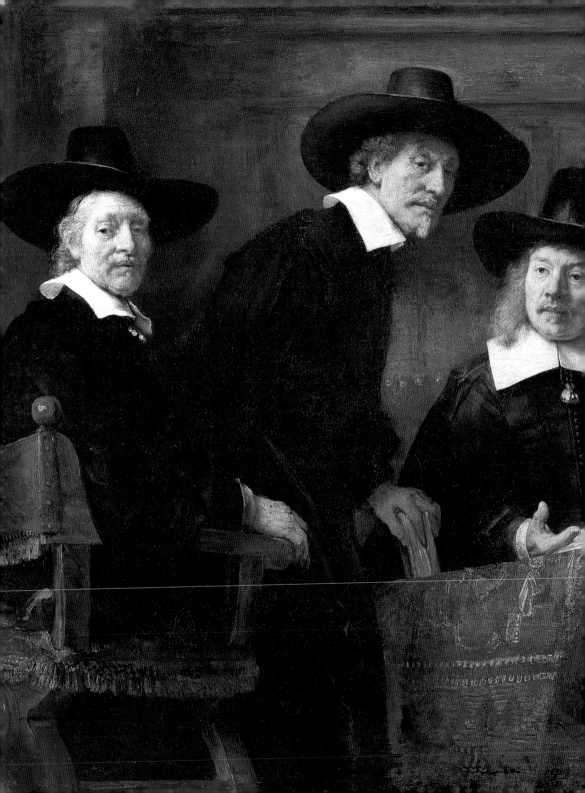

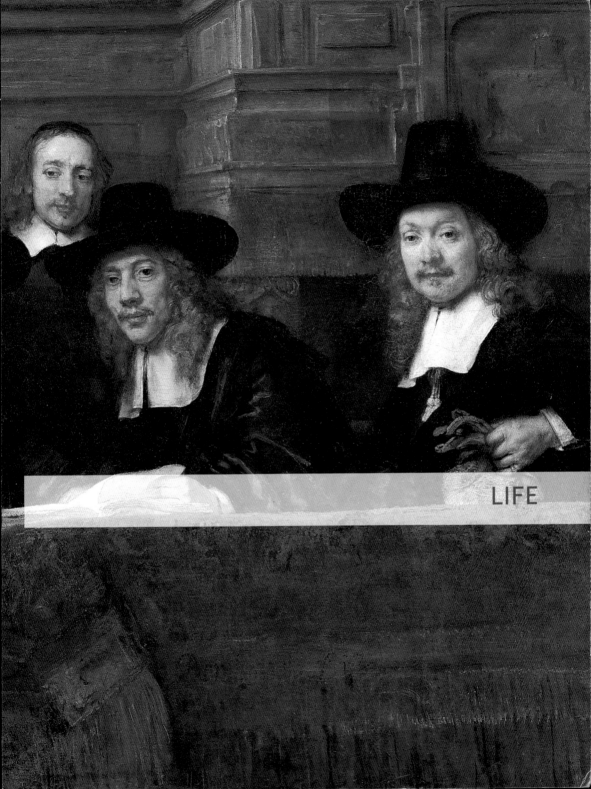

LIFE

The Power of Color and Light

The career of one of the world's most important artists began in the provinces, where there was still no clear distinction between artists and craftsmen. To be a painter required above all a great deal of patience in the Netherlands in the early 17th-century, at least in Leiden, the town of fine, detailed painting, where Rembrandt did his training and where the value of a painting was judged by the length of time it had taken to paint it.

The miller's son sets up a studio

Rembrandt was born in Leiden on 15 July 1606. His father, Harmen, owned a mill beside the course of the Old Rhine, which marks the town boundary on the northern side. It was from here that Rembrandt's family got its name, van Rijn. His mother Cornelia, known as Neeltje, was the daughter of a baker. Of the nine children, all the other surviving sons learned a trade; only Rembrandt was sent to the Latin School in Leiden so that he could subsequently take up his studies and later enter a profession. But he soon decided to become a painter. Although the miller's son later gained access to upper-class society, he remained a simple man all his life; his personal preferences seem simple, if not a little coarse: basing his comments purely on hearsay, the Italian art writer Filippo Baldinucci described Rembrandt as being ill-mannered, having an "ugly and plebian face" and as typically wearing "dirty clothes as it was his habit when working to wipe his brushes on himself."

Rembrandt learned the basic skills of painting from Jacob Isaaczoon van Swanenburgh, a painter in Leiden who specialized in landscapes and representations of Hell. His style was very traditional but revealed that he had direct knowledge of Italy and Italian art; moreover, he was married to a Neapolitan woman. It was through him that Rembrandt was first encouraged to study the art of the Renaissance and Italian painting. In 1642 Rembrandt spent six months in the studio of the successful painter Pieter Lastman in Amsterdam, who was considered to be one of the best and most modern representatives of the "Italian Style" in the Netherlands. It was from Lastman that Rembrandt learned important ideas with regard to subject matter, his teacher making him tackle narrative topics as well as dramatic events. Many of Rembrandt's early pictures on biblical themes reveal the influence of the Amsterdam master.

Back in Leiden, Rembrandt became an independent artist and moved into a shared studio with Jan Lievens, who was about the same age. Lievens, too, was a talented young painter. The two of them painted each other and the same subjects—an original way to learn their craft and to master their own individual styles with greater confidence. Rembrandt soon discovered his talents as a portrait painter, and at the same time began to make drawings and etchings. In the meantime, his two eldest brothers took over the running of the mill from their father, who was gravely ill.

Opposite:
Hunter with Bittern,
1639,
Gemäldegalerie,
Dresden

Self-portraits

Since time immemorial, gazing into the mirror has always been the most direct way for an artist to confront reality. Rembrandt practiced this method from the beginning of his career as an artist, and painted self-portraits countless times in the course of his life. The earliest of these self-portraits are to be found today in Kassel, Amsterdam, Munich, and The Hague. The stations of Rembrandt's public life and inner development can be traced on an almost annual basis in the likenesses he painted of himself. In their merciless intensity they are comparable only with the self-portraits of another Dutch painter: Vincent van Gogh. As a young man Rembrandt found it amusing to pull faces in his pictures, to portray himself as a beggar in rags, as a soldier with his chest puffed up with pride, or as a philosopher in Oriental costume. Rembrandt's *The Artist in His Studio* of 1628, today in the Museum of Fine Arts in Boston, is a reflection on the role of the artist. Later, when he had risen into the fine society of Amsterdam, he learned to tend his beard and hair and made good use of the many wonderful items in a huge collection of objects he had acquired, like props in a theater. He brought out broad-brimmed velvet hats, magnificently frilly shirts, golden chains, doublets with puff sleeves and flowing velvet cloaks—and then posed in front of a mirror. In later years Rembrandt painted himself as of a prosperous man who was satisfied with himself and his achievements, a man who could permit himself the

odd extravagance. Then followed the years of economic ruin, in which the painter appears as a master of his art, solemn and sober in expression, dressed in simple working clothes. Toward the end of his life Rembrandt saw in the mirror the features of a man who had been put to the test by fate, but who had retained his dignity to the end. He may have been a failure in everyday life, but as an artist he was triumphant.

Early recognition

But we should not anticipate events. We are still with Rembrandt in his mid-twenties, in his studio, which he shares with his friend and colleague Pieter Lievens.

In 1628 Constantijn Huygens, the learned scholar, poet and influential diplomat at various European courts, undertook a journey to the cultural centers of the Netherlands, among which was Leiden. This town on the northern course of the Old Rhine was the seat of the oldest university in the Netherlands and had undergone an arduous siege by the Spanish troops during the Dutch War of Independence. In Leiden, noted Huygens later, he had met a "noble pair" of young painters who worked together side by side in a shared studio: Jan Lievens and Rembrandt van Rijn. Although they were not much older than twenty, Huygens was enthusiastic about the talents of them both, especially as they came from humble circumstances. Huygens' account reveals unequivocal admiration of the two young men. He observed, perceptively, that Lievens was "superior in invention and

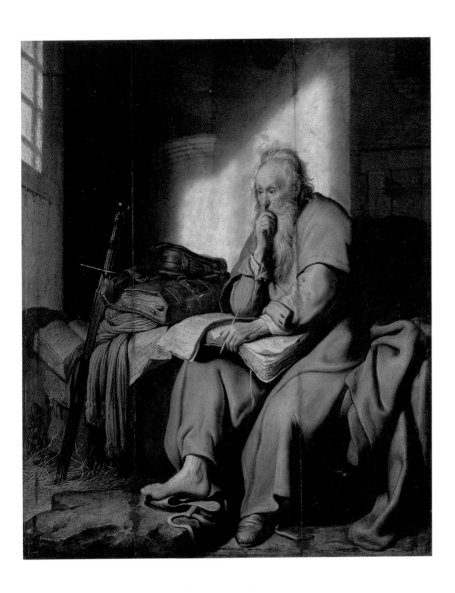

St. Paul in Prison,
1627,
Staatsgalerie,
Stuttgart

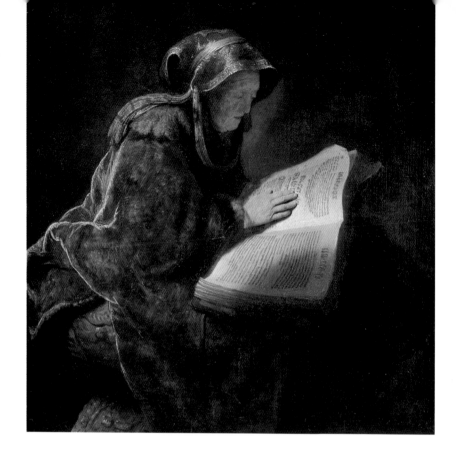

*Rembrandt's Mother
as the Prophetess
Hannah,
1631,
Rijksmuseum,
Amsterdam*

a certain grandeur in his daring themes," while Rembrandt "surpasses Lievens in his sure touch and in the liveliness of emotion." Rembrandt's paintings still adhered to the range of what was generally accepted at the time: character heads or biblical stories, painted on wood and executed with great care as regards the details and light, and mostly in smallish formats. Indeed, the paintings of Rembrandt and Lievens had hitherto complied with the typical Leiden preference for a finely chiseled, meticulously executed style of painting. Nonetheless, Huygens was convinced that the two of them would succeed in positioning Dutch painting at the very forefront of European art.

As far as Lievens was concerned, the prediction was perhaps a little bold (Huygens even had his portrait painted by Lievens and not by Rembrandt). As far as his studio colleague was concerned, however, the prophecy was most definitely an accurate one. Huygens' encouraging words and praise were not without effect. Before long sleepy Leiden, where the circles who set the tone in cultural matters cultivated a genteel, ultimately conservative taste, became too narrow for Rembrandt's artistic ambitions. Encouraged by the recognition

he had received from people with intellectual influence, notably Huygens, he set off for new horizons.

Amsterdam

On 20 June 1631 Rembrandt came to a commercial arrangement with Hendrik van Uylenburgh, an art dealer for Amsterdam's fine society, and moved to the Dutch capital. In a northern Europe that had been devastated by the Thirty Years' War, Amsterdam had remained an oasis of peace and quiet, in which trade and commerce prospered as nowhere else. Overseas trade had made Amsterdam a cosmopolitan city and a cultural metropolis. Though in general religious freedom prevailed, the predominant Calvinism forbade pictures in churches, so that Rembrandt could not expect commissions for altarpieces or devotional images. He therefore concentrated on the wide-ranging requests of private collectors, municipal guilds, and public institutions.

His first commission opened the door to the flourishing Amsterdam art market. The group portrait shows the participants at a public autopsy by the famous anatomist Dr. Nicolaes Tulp, held annually at the headquarters of the Amsterdam guild of surgeons. *The Anatomy Lesson of Dr. Nicolaes Tulp* (1632, Mauritshuis, The Hague) is in every respect an unusual painting which nonetheless belongs to the local tradition of such group portraits and could doubtless be appreciated by his contemporaries. Rembrandt was justified in hoping that he would be able to become the most impor-

tant painter in the Netherlands, rivaling Rubens and the masters of the Italian Renaissance. With this in mind, he began to sign his paintings, as had Leonardo, Raphael, and Titian, with only his baptismal name, Rembrandt, without adding his patronymic, Harmenszoon, or his family name, van Rijn.

As noted above, there was no call in the Calvinist Netherlands for altarpieces or devotional paintings, which represented an important field of activity for artists in Catholic countries. And in the field of mythological pictures, the commissions were initially restricted to smaller scenes, like the abduction of Europa or Proserpina, and depictions of Andromeda or Diana. Only in later years did Rembrandt produce large-format pictures on subjects from antiquity.

The painter from Leiden soon rose to become the preferred portraitist of the upper class. Several dozen individual portraits date from his first years in Amsterdam. They invariably show ladies and gentlemen dressed in black with stiff white collars or ruffs. The stiffness and austerity of the clothing was intended to express the moral rectitude of the person in the picture—which, however, did not prevent Rembrandt, who was a good judge of character, from finding convincing, sometimes even brilliant, picture solutions for each individual case.

Rembrandt's most important portraits are much more than mere representations of the person they portray. Rather, he designs complex works at the center of which lies an event, an action. Like Caravaggio,

whom he knew only from copies, Rembrandt had realized that it was a matter of allowing viewers to feel that they are taking part in the event depicted in the picture. The secret of these works is revealed in the flow of energy between the picture and the viewer. Of course, there had been portraits since the Renaissance, starting with those of Jan van Eyck in Flanders and Antonello da Messina in Italy, which had established a close relationship to the viewer. Earnest and pensive, the sitters remain mute and unreachable, as though existing in another world. Only intellectual reflection made these pictures speak. In Rembrandt's case it was different. As a painter he was a typically Baroque personality–lively, curious, always on the move. His portraits challenge the viewers' gaze and involve them in an animated event; in this, Rembrandt had only one true predecessor: the great Venetian, Titian. Rembrandt's painting style was equally animated and dynamic, developing from the detailed, calligraphic style of his early works to the intense, sometimes somber colors and roughly sketched paintings of the later years. The veracity of his portraits reveals an uncompromising scrutiny of the reality of the individual which Rembrandt exercised like virtually no other among his contemporaries.

Saskia and the years of success

Through his business partner, the art dealer Hendrik van Uylenburgh, Rembrandt met van Uylenburgh's cousin, Saskia. A number of paintings dating from this time bear witness to the love which developed between the two young people, and Rembrandt and Saskia soon became betrothed. They were married on 22 July 1634, after a one-year period of betrothal. Saskia brought a considerable dowry to the marriage, but before long members of her family began to voice their concerns at Rembrandt's careless handling of their joint fortune. Rembrandt, however, was at the height of his success as a painter and could easily afford to ignore their misgivings, for he was earning well and, it seemed, embarked on a promising career. He and Saskia moved home several times so that he would have sufficient space for the growing number of pupils, who paid large sums of money to be taught by him. Those citizens who wanted to have their portrait painted by Rembrandt had to wait for some time because of the number of commissions he received. Rembrandt was well on his way to becoming the most famous painter in the Netherlands. The composition of his paintings became increasingly complex, the formats ever larger. As a picture ground, Rembrandt now no longer used wood panels, as at the beginning, but canvas, which was easier to manage and provided more texture. In addition to portraiture, which represented the main focus of his work, he also turned his attention to traditional themes from the Bible, classical mythology, and history. Most important in this respect is the five-part Pas-

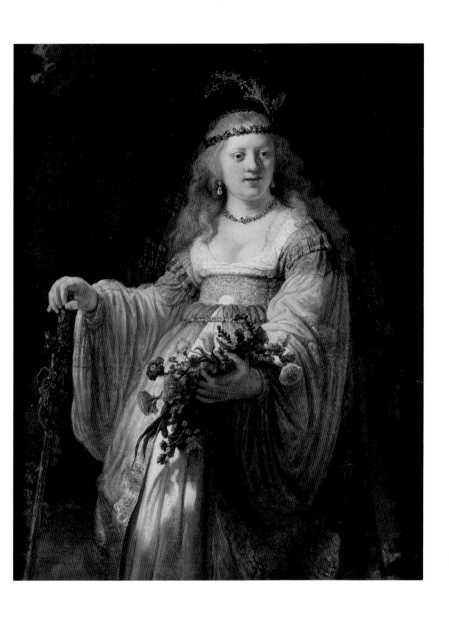

Saskia as Flora,
1635,
National Gallery,
London

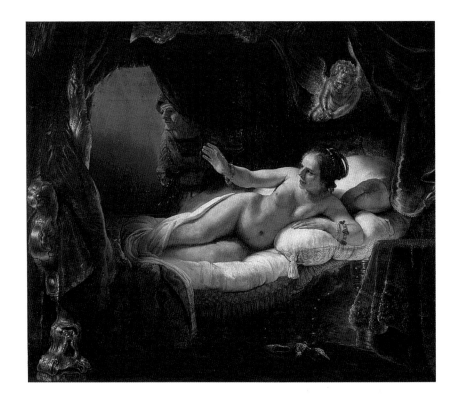

Danaë,
1636–1654,
The State Hermitage
Museum,
St. Petersburg

sion Cycle, kept today in the Alte Pina-
kothek in Munich, which Rembrandt
worked on for ten years from 1634. It was
commissioned by Frederik Hendrik, Prince
of Orange, after Constantijn Huygens had
drawn his attention to Rembrandt's talent.
As a gesture of thanks for establishing the
contact, Rembrandt sent Huygens the
most dramatic work he ever painted: *The
Blinding of Samson* (1636, Stadelsches
Kunstinstitut, Frankfurt).

Rembrandt was now also busy as a print
maker—a lucrative market appealing to
those who could not afford paintings—and
his etchings would become some of the
very finest in the medium.

In a cosmopolitan trading city like Am-
sterdam, Rembrandt could cultivate con-
tacts with representatives of a wide variety
of nationalities and religious confessions.
The models for his portraits included
Calvinists and Arminian Christians as well
as Catholics and Mennonites, Anabaptists,
Jews, and Muslims. These acquaintances
may well have contributed to the fact that
in religious matters Rembrandt main-
tained a decidedly tolerant attitude. Al-
though he was formally a Calvinist, he took
no part in the life of the congregation and
never attempted to cultivate close contacts
with the official Church, a fact that led to a
good deal of public disapproval.

A passion for collecting

Driven by an insatiable passion for collecting, but also in order to have objects as models for his own pictures and as subjects for the drawing and painting exercises of his pupils, Rembrandt began to assemble a collection which can truly be described as encyclopedic, thereby incurring the disapproval of Saskia's family, who suspected that he was squandering his wife's dowry in the process. It contained not only works of art but also exotic and scientific curiosities of all kinds, from Oriental weapons and precious fabrics to stuffed animals. In some ways Rembrandt's collection served him in place of travel, for which he apparently felt little inclination; he was the only great artist of the 17th century never to have to travel to Rome. However, even better than his own collection of Old Master paintings, high quality though it was, Rembrandt was able to study the developments in European art during the Renaissance and the Baroque through his comprehensive collection of drawings and prints. He possessed individual sheets and entire albums of drawings and etchings or engravings by Andrea Mantegna, Raphael, Albrecht Dürer, Martin Schongauer, Bruegel the Elder, and other Old Masters, as well as copies after Titian, Peter Paul Rubens and Anthony van Dyck, a number of erotic engravings by Annibale Carracci and Rosso Fiorentino, and even some Indian book illustrations. For reference purposes, Rembrandt had arranged this collection of graphics according to main subject: male and female nudes, architecture, classical statues, and landscapes. The possession of such a comprehensive collection that was accessible at all times thus permitted him to compare his works with those of his great predecessors and near contemporaries. For art writers of the time, the fact that he had never been to Italy to study the legacy of classical antiquity and the art of the Renaissance provided grounds for criticism. Rembrandt preferred to "travel" in his studio with the help of his imagination, surrounded by the treasures of his collection. It was his ceaseless curiosity and his unerring artistic judgment that enabled him to take up the challenge of the great masters from a distance.

The house on Breestraat

In the whirl of this success Rembrandt embarked on a financial adventure which would eventually lead to his ruin. In 1639 he acquired a property on Breestraat (Sint Anthonisbreestraat) in the heart of a district half-way to the city center where most painters who were resident in Amsterdam had their lodgings.

The agreed purchase price was the sum of 13,000 guilders, of which Rembrandt initially paid only a small part. He never succeeded in paying the remainder. In addition to living accommodation for the artist and his family, the building included space to house Rembrandt's extensive collection of art and curiosities. The studios where the master and his numerous pupils worked extended across several floors, and so that

the models did not get cold while sitting for long periods, the rooms had their own stoves.

The property, which is known today as the Rembrandthuis, and which houses a museum with works by the artist, must have been a veritable hive of activity during the artist's lifetime. Apprentices and suppliers, customers and models thronged the house and courtyard. Rembrandt's collection of artworks and objects was a real attraction for traveling scholars and lured visitors from all over Europe.

Zenith and decline

As an artist, Rembrandt could claim a great deal of success during these years, a fact that is also expressed in the confident pose which he adopts in his portraits from this time. His clothes also reveals increased social aspirations. However, Rembrandt was not spared a number of bitter losses. Between 1635 and 1639 Saskia bore him three children, all of whom died shortly after birth. In September 1640 his mother Cornelia died in Leiden. Later in the same month, Rembrandt's only son to survive to adulthood was baptized Titus in the Zuiderkerk in Amsterdam (in memory of Saskia's older sister, Titia van Uylenburgh, who had died young). But then, scarcely a year later, in June 1642, Rembrandt's beloved wife Saskia, who had never recovered from the exertions of childbirth, died of consumption.

These human tragedies occurred when Rembrandt was celebrating his greatest success as an artist. In 1640 the citizens' militia of Captain Frans Banning Cocq had commissioned a group portrait which was completed in 1642 and which went down in history as *The Night Watch*. The lively composition, dynamic and full of movement, avoids the conventional group portrait, which was a mere lining up of individual faces without a narrative connection. Saskia's death marked a break in Rembrandt's creative work; from now on he used more somber colors and began simply to hint at contours and features rather than to execute them in detail.

In order to take care of little Titus, who had a delicate constitution, Rembrandt took Geertje Dircx, the widow of a ship's bugler, into his house; before long she became his mistress. Between 1642 and 1645, Rembrandt dedicated himself on several occasions to the subject of the Holy Family; of particular note in this respect are the *Holy Family with Angels* (1645, The State Hermitage Museum, St. Petersburg) and the *Holy Family with a Curtain* (1645, Gemäldegalerie, Kassel). Another motif which Rembrandt took up a number of times during these years was that of young girls on the verge of womanhood, for example in the subject of the wedding night and often with reference to biblical stories. In this context belongs the delicate and yet monumental scene *The Woman Taken in Adultery* (1644, National Gallery, London) as well as *Danaë* (1636, The State Hermitage Museum, St. Petersburg). In the latter, the nude figure of

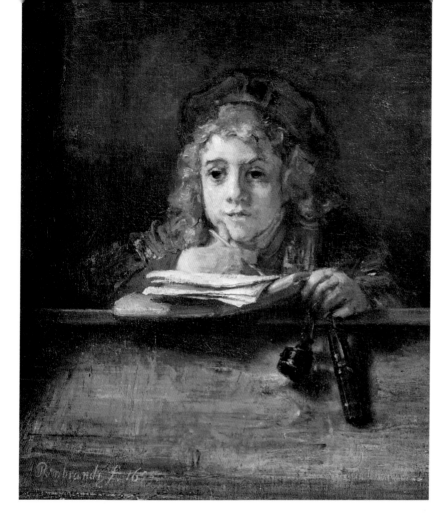

Danaë, stretched out on her couch in all her radiant beauty, reveals clear references to works of the Italian Renaissance. In 1985 the painting was sadly severely damaged when a mentally deranged visitor threw acid on it.

During the 1650s Rembrandt also painted a number of very charming landscapes.

Although Rembrandt was already struggling under financial problems at this time, he could still rely on the support of influential friends in Amsterdam. The most important of them, Jan Six, a future mayor, is regarded as one of the best aficionados and patrons of Rembrandt's works.

Hendrickje Stoffels

In 1649 Rembrandt's relationship with Geertje Dircx ended in a court of law. After he was found guilty of breach of promise,

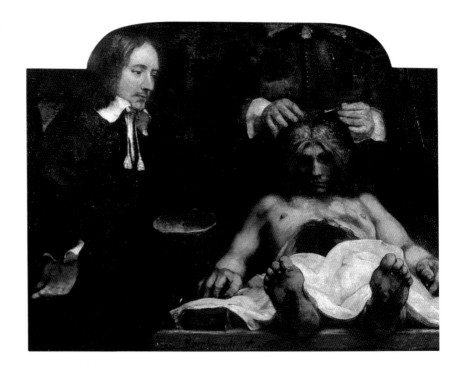

his former nursemaid and mistress was found guilty of stealing jewelry from the estate of Rembrandt's deceased wife, Saskia, and was sent to a house of correction. Among the witnesses who testified against her we also find the name of Hendrickje Stoffels, a peasant girl who could scarcely read and write. She soon became Rembrandt's companion and remained by his side even during the years of financial decline. A daughter was born in 1654; she was baptized Cornelia, after Rembrandt's mother. It is significant that not a single portrait of the daughter has survived, not even a drawing. By contrast, Rembrandt painted several pictures of his son, Titus. Especially touching is the portrait of 1655 which shows the boy sitting pen in hand,

thinking (*Titus at His Desk*, Boymans van Beuningen Museum, Rotterdam).

In 1650 Rembrandt began once more to add to the series of self-portraits, which he had neglected for some time. From now on they show a man whose features and figure become increasingly heavy with age. This is especially evident in his *Self-Portrait* of 1652, in which he stands with his hands on his hips (Kunsthistorisches Museum, Vienna). While a decade previously the painter had still stylized himself in the manner of a Rubens or even a Titian, here he faces the viewer in simple working clothes, in the pose of an artist who is aware of his artistic abilities and the effort and responsibilities this entailed. In some paintings of

around 1654 Rembrandt depicted his companion, Hendrijke Stoffels.

A change of style and fortunes

At this time a decisive stylistic change can be observed that led Rembrandt to a method of applying paint thickly, in an almost sculptural manner. This can be seen in three main works: the *Portrait of Jan Six* (1654, Six Collection, Amsterdam), possibly Rembrandt's most revolutionary portrait; the moving biblical scene *Jacob Blessing the Children of Joseph* (1656, Gemäldegalerie, Kassel); and finally in this category, the densely atmospheric scene *Aristotle with a Bust of Homer* (1653, Metropolitan Museum of Art, New York), painted by Rembrandt as the first of several works for the connoisseur and collector Antonio Ruffo, who lived in Messina, and with whom Rembrandt maintained a long-lasting relationship which was, however, not always free from differences of opinion.

The end of the Thirty Years' War brought a need for cultural renewal in the Netherlands, for greater magnificence, and for contact with the international developments in style—aspirations that found expression in the impressive architecture of Amsterdam's neo-classical New Town Hall, begun in 1648. Rembrandt's painting style, which was becoming progressively denser and more somber, offered few points of contact with the taste of the new upper class, which was focused on simple, clear representation and classical forms.

During the course of an artistic career spanning more than forty years, Rembrandt's style underwent a development which can be clearly traced. Only with the knowledge of this development is it possible to recognize in the delicate, calligraphically executed paintings of his early work the same artist as the one who created the scenes committed to canvas with rapid, cursory brushstrokes and thickly applied paint during his later years. Today the paintings produced by Rembrandt during the last fifteen years before his death are regarded as some of the most atmospherically dense and artistically impressive artworks of all time; however, they were not infrequently rejected and provoked incomprehension in his contemporaries and customers. At the same time as Rembrandt was developing a painting style of suggestion and indistinct contours, the taste of the general public turned towards clear, precisely defined lines, light colors, and classical forms.

Bankruptcy

The declining interest in his painting, with some customers rejecting works they had ordered or demanding extensive changes, was one of the main reasons why Rembrandt's financial situation became increasingly difficult. One after the other, his influential friends turned away. At the same time, the burden of debt for his house continued to grow. By 1656 Rembrandt had paid only half of the 13,000 guilders which had been agreed when he bought it in 1639;

the original agreement was that the full amount would be paid in five to six years. Bankruptcy was now inevitable. The court ordered that an assessment of his assets be drawn up. All attempts to pay off the debt, including the participation of the artist's influential friends, failed. In July 1656, Rembrandt' entire possessions located within the house in Breestraat, including his paintings, drawings and prints, were listed in an inventory. The auction, during which his house and nearly all his possessions were sold, took place in three stages during the following year. The inventory contained a total of 363 entries and in its way represents a unique record of the property and lifestyle of the artist. It lists some fifty paintings by Rembrandt's own hand, as well as an impressive number of Old Masters from his collection, portfolios and albums with valuable drawings, etchings and engravings, together with collector's items from overseas, items from faraway India, no fewer than seventy stuffed sea and land creatures, Oriental battle axes inlaid with silver, busts of Roman emperors, casts of classical statues, the death mask of Price Maurice of Orange, shells from the shores of distant oceans, four cushions, a pewter water jug, glass bottles, a games board, a stuffed bird of paradise, pans and kitchen stools, the artist's bed complete with quilts, mattresses and bedwarmer, and a handful of books, scarcely totaling twenty, including a much-read Bible and a copy of *Medea*, a tragedy after the classical original written by Rem-

brandt's friend Jan Six. The proceeds of the auction raised only a fraction of the actual value of the goods and failed to free the artist, who now found himself literally on the street, from his debt; he had lost his house and his possessions, his studios, and his pupils—and also, apparently, his contact with the predominantly classical taste of the times.

And yet the very personal portraits created during these years show a lighthearted equanimity which did not forsake the artist even in difficult times. These include the contented portrait of his son, *Titus Reading* (c. 1657, Kunsthistorisches Museum, Vienna) and a self-portrait that shows the artist visibly older but with an air of imperturbable authority, finely dressed and holding a cane (1658, Frick Collection, New York).

The negotiations in connection with a number of commissioned works, including those for the Sicilian collector Antonio Ruffo, provide insight into Rembrandt's financial situation, which continued to be precarious. In 1659 he and his family moved into a modest house on Rozengracht. In order to avoid losing the whole of his remaining possessions, Rembrandt transferred the rest of his goods to his son Titus and Hendrickje Stoffels, who, since she was unable to write, signed the notary's document with a cross. It was at this time that Rembrandt produced a series of half-portraits of the Apostles; today they are scattered in a number of locations. He also painted the impressive *Peter Denies Christ* (1661, Rijksmuseum, Amsterdam),

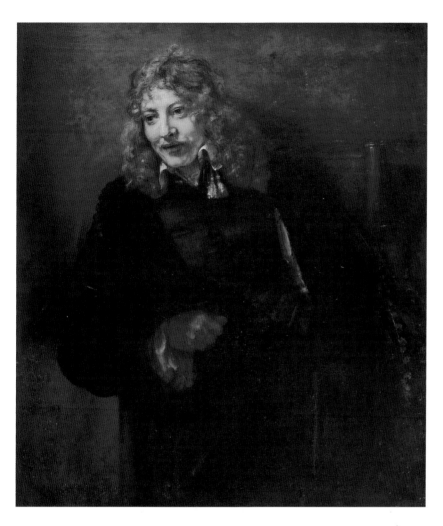

as well as a number of self-portraits which mostly show him in working clothes; and finally the *Portrait of Jacob Trip* (1661, National Gallery, London), a portrait of an old man with the aura of an Old Testament patriarch.

After some considerable time, in 1662 Rembrandt received another prestigious public commission, this one from a guild: the group portrait the *Sampling Officials of the Drapers' Guild* (1662, Rijksmuseum, Amsterdam). However, his most important official commission was the large-format historical painting *The Conspiracy of Claudius Civilis* for the recently completed New Town Hall in Amsterdam (1662, National-

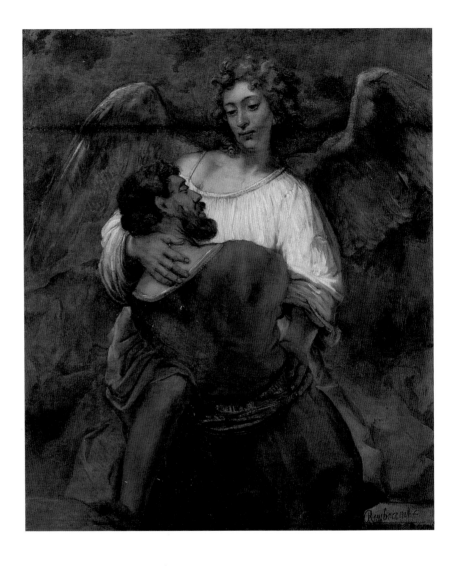

museum, Stockholm), a work that was ulti-
mately rejected by the civic authorities.

His last years
In July 1663 Hendrickje Stoffels died of the
plague. Rembrandt's last years were spent
in a loneliness which is reflected in a se-
ries of deeply moving masterpieces. Far
removed from the stylistic developments of
his age, Rembrandt's paintings give ex-
pression to the deepest emotions of their
creator. The self-portraits of this period

show a man who ages before our eyes. The facial features become heavy and pasty, the beard sparser; his eyes have a lost look about them. All the more energetic and decisive is the painterly technique in these paintings, in which the paint acquires an almost three-dimensional quality. Rembrandt was not using thinly applied transparent glazes (the conventional technique), but thick, heavy masses which he modeled with the paintbrush and in some places even with his fingers to form areas of paint which rise out of the surface of the painting.

But fate had one last tragedy in store for Rembrandt. In 1688 his much-loved son Titus married Magdalena van Loo, a happy occasion which Rembrandt recorded in the double portrait known as *The Jewish Bride* (c. 1667, Rijksmuseum, Amsterdam). Barely seven months after the wedding, Titus, whose wife was expecting his child, died of the plague at the age of twenty-six. It was as if Rembrandt was turned to stone by the pain. His grief is expressed in the both alarming and touching *The Return of the Prodigal Son* (c. 1668, The State Hermitage Museum, St. Petersburg), a moving portrayal of paternal love and the expression of the artist's profound longing for peace.

Rembrandt's granddaughter was born in March 1669. She was baptized Titia and Rembrandt acted as godfather—a last, brief moment of happiness. One last time the artist stepped before the mirror, looked at his face, bearing as it did the signs of old age and suffering, and found the strength

for an unsparing stock-taking—perhaps in remembrance of Saskia, whom he had painted once more shortly before her death, smiling, a carnation in her hand (*Saskia with a Flower*, 1641, Gemäldegalerie, Dresden). In his last *Self-Portrait* (Mauritshuis, The Hague), Rembrandt faces us in black clothing before a bleak background; shadows fall deeply across his face. And yet he radiates an expression of tender devotion. He is tired, lonely, and alone—but he is not broken.

A lonely death

In September 1669 Allaert van Everdingen, also a painter, visited Rembrandt. It was not a mere courtesy call, for van Everdingen brought his son Cornelis with him so that the boy could get to know the work of an artist who had formerly been one of the most famous masters of Dutch painting; it was planned that Cornelis, too, was to learn the artist's trade.

While the usual friendly greetings were being exchanged, the two visitors looked around Rembrandt's impoverished home in case there was an interesting picture there for them to admire. They eventually discovered on the easel a still largely unfinished oil painting which seemed at first glance to be a *Presentation of Christ in the Temple*.

On 2 October another visitor knocked at the door of the house in Rozengracht. It was Pieter van Brederode, an amateur local historian. He was looking for objects relating to the history of Amsterdam and had heard of a piece in Rembrandt's collec-

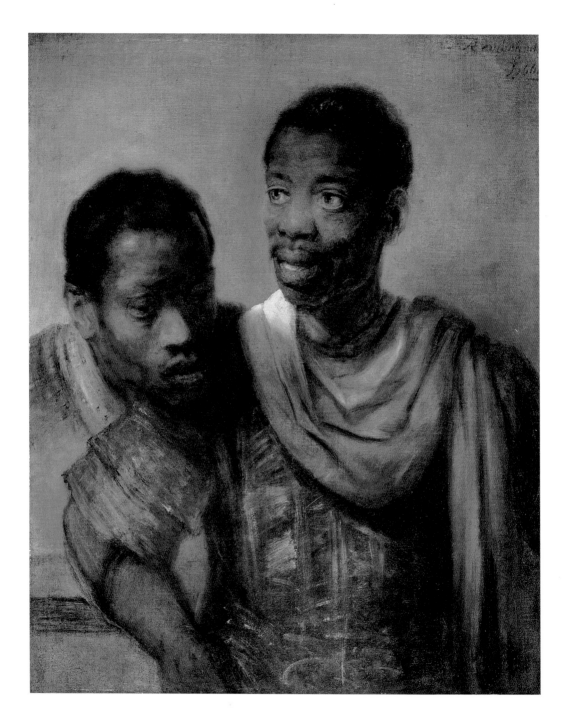

tion; its legendary treasures (some of which he managed to save) still meant something. It was supposed to be an ancient helmet, and indeed the researcher found in Rembrandt's home a medieval helmet which he examined in great detail. Van Brederode also looked around and, as he later noted, remembered seeing a number of other objects in the artist's studio which aroused his interest, including another helmet, possible from Roman times. With horror he studied casts of human arms and legs, prepared "in the style of Vesalius." Rembrandt himself seemed to his visitor to be in the best of health.

But only two days later, on 4 October 1669, Rembrandt was no longer alive. It was not possible to ascertain any specific cause of death, neither an illness nor an accident. Rembrandt died alone, in the silence of his room, without having suffered a long and painful decline. As in the case of Titian, no priest came to his deathbed. The man who was not pious but who knew the Bible so precisely, died without the support of the Church.

Rembrandt left no will, because in any case officially he owned nothing. A notary was summoned and produced a meticulous list of the few possessions to be found in the house of the dead man. There was nothing of value: simple furniture, bridal linen, the bare household necessities, and all sorts of paraphernalia. The artist's palette was hanging on a hook in the wall; in front stood his easel, and beside it pots of color which were slowly drying out. The number of paintings barely totaled fifty. The property inventory of 1656, by contrast, contained 363 entries, many of them of considerable value. Finally, locked away in a little cupboard there was a carefully tied bag of gold coins. It was just enough to pay for a modest funeral.

The parish clerk noted in the register of deaths within the parish, under the date 8 October 1699: "Rembrandt van Rijn, painter, of Rozengracht opposite the Doolhof. Coffin with 16 bearers. Leaves two girls [Rembrandt's daughter Cornelia and his granddaughter Titia]; received: 20 guilders."

The painting which stood on Rembrandt's easel until the end was the unfinished *The Presentation of Jesus in the Temple* (Nationalmuseum, Stockholm). It shows the aged Simeon, who, holding the newborn Messiah in his arms, sings a song of praise and hope to the child. It was thus that Rembrandt had carried his granddaughter Titia to church to be baptized, and it seems as if the painter saw himself for one last time in one of his figures in the picture.

"When Rembrandt died in 1669, Newton had broken up light into its spectrum, Molière had presented *Le Misanthrope* on the stage, and Milton had finished his *Paradise Lost*. A massive curtain began to fall on the certainties of European man, even if his acts of power would long deceive him into thinking it was not so." Thus Giovanni Arpino interpreted Rembrandt's death—the artist as a symbol of an age coming to an end.

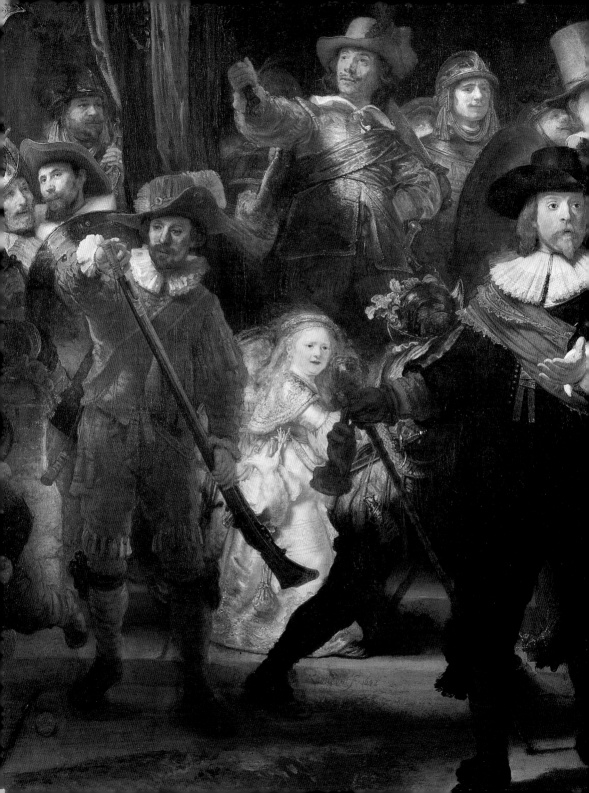

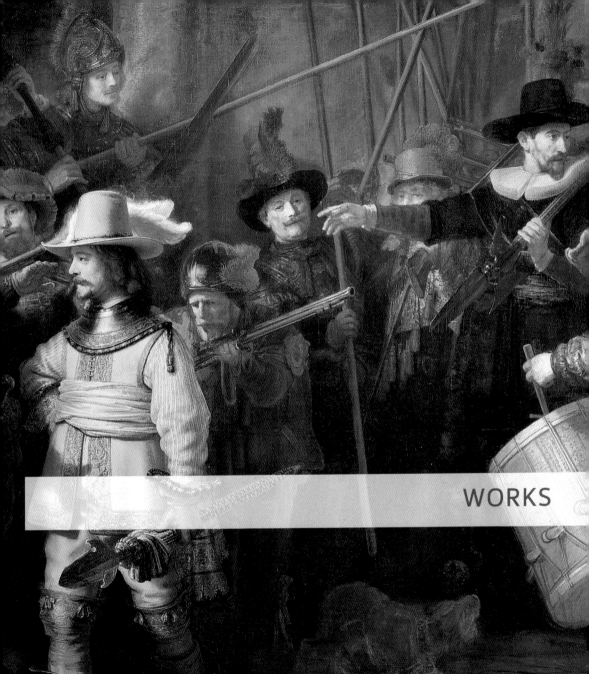

WORKS

The Stoning of Saint Stephen

1625

Oil on wood, 89.5 x 123.6 cm
Musée des Beaux-Arts, Lyon

The dating and the abbreviation "RF" for "Rembrandt fecit" ("Rembrandt made this")
identify *The Stoning of Saint Stephen* as the first work that can be attributed to the artist
with any certainty. The elegant, finely detailed style in which the figures are executed
corresponds to the taste prevailing in Leiden at his time. On the other hand, the exten-
sive scope of the painting's composition, the dramatic gestures, and the hazy light above
the scene reflect the impressions Rembrandt gained shortly beforehand, during a six-
month visit to the studio of the then celebrated artist Pieter Lastman in Amsterdam. The
ruins in the background can also be traced back to Lastman's influence.

The Stoning of Saint Stephen is one of the first paintings to have been created in the joint
studio that Rembrandt had opened with Jan Lievens in Leiden. These two talented young
painter friends took pleasure in incorporating their own likenesses into the scenes that
they painted, while swapping roles and styles. Here, their faces appear next to that of the
early Christian martyr. Rembrandt's features are also recognizable in those of the ex-
ecutioner, who lifts a stone with both hands, ready to hurl it at the deacon. Until the very
end, Rembrandt represented himself again and again in his own paintings, both quite
openly and also in obscurer, emblematic ways.

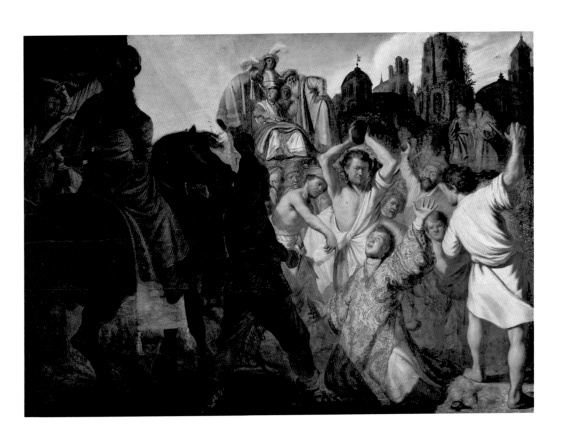

Tobit and Hanna with a Kid

1626

Oil on wood, 39.5 x 30 cm
Rijksmuseum, Amsterdam

This small masterpiece from the early Leiden period was created when Rembrandt was just twenty years old. It already features numerous elements of a technical, stylistic and thematic nature that would become characteristic of Rembrandt's later work. Even in this early piece, he demonstrates his ability to draw on subjects from Holy Scripture that had seldom or never been depicted in art. We can see here his effort to reproduce the concrete quality of objects in an almost tangible manner through the application of color and through brushwork. The great importance accorded to the subject of blindness and sight by Rembrandt is another distinctive feature of this painting.

The old man Tobit has lost his eyesight and now awaits the return of his son Tobias, who is to relieve him of his affliction. The figures' expressive, almost theatrical gestures are also typical of this stage of his career. Rembrandt's interest in the reality of things, already well developed at an early age, is everywhere in evidence. The painter has inscribed the painting on the lower left-hand edge with the year "1626" and the monogram "RH" (Rembrandt Harmenszoon), with which he signed his paintings during the early years of his career.

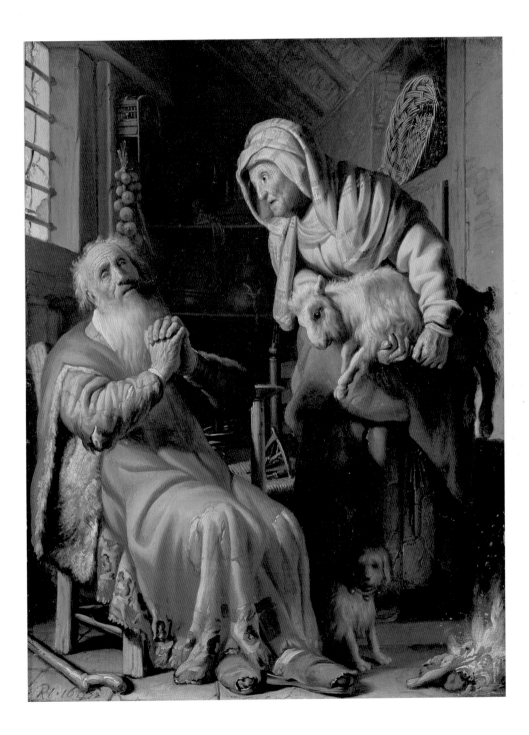

The Money Changer (The Parable of the Rich Fool)

1627

Oil on canvas, 32 x 42 cm
Gemäldegalerie, Berlin

Close to the light emitted by a candle, an old man with spectacles perched on his nose examines a coin. To this day, no consensus has been reached about the actual subject of this painting. Some regard it as the representation of the Parable of the Rich Fool from the Gospel According to Saint Luke (12:13–21), while others recognize in it the satirical portrait of a money changer. Yet others understand this to be an allegory of greed. The wide range of different interpretations is evidence of the associative power of this small painting, whose message lies beyond iconographic conventions. Rembrandt's generally reliable biographer Arnold Houbraken reports that the artist's motto was "For the sake of my soul, I do not strive for glory but for freedom!" This painting is unequivocal testimony to the independence of the twenty-year-old Rembrandt.

The motif of the candle illuminating the piles of books, papers, and other objects in its vicinity is reminiscent of the chiaroscuro of the Utrecht-based heirs of Caravaggio—Gerard van Honthorst, Hendrick ter Bruggen, and Dirck van Baburen—whose paintings Rembrandt had studied attentively in his youth. The monogram "RH," with which the painting has been signed, stands for "Rembrandt Harmenszoon," placing the painter's patronymic after his given name, according to Dutch custom. In documents from his early years as a painter in Leiden, Rembrandt is consistently referred to as "the miller's son."

Self-Portrait at an Early Age

c. 1627

Oil on wood, 23 x 17 cm
Rijksmuseum, Amsterdam

Rembrandt recorded his external and internal development over the years using all artistic techniques available to him, from drawings and etchings to oil paintings. This led to a rapid succession of self-portraits whose human and psychological depth can be compared only to those of another Dutch painter, Vincent van Gogh.

Rembrandt's self-portraits also provided him with the opportunity to experiment with body postures, poses, facial expressions and grimaces, unhampered by the expectations of patrons. Most importantly, however, they allowed him to try out new styles and ways of painting. While his brushstrokes were, at first, fine and deftly placed, he would later develop a broader brushstroke and a heavy, thick application of color. In the early works from the time of his move to Amsterdam, the young Rembrandt retained the delicate and highly detailed painting style practiced in his hometown of Leiden. In this painting, one can also detect his pleasure in formal experimentation, however: where, for example, some of the wild curls around Rembrandt's head are not painted, but have been scratched into the paint with the tip of the handle of the paintbrush, so that the primer becomes visible. There are several versions and copies of this painting, some of which are of questionable authenticity.

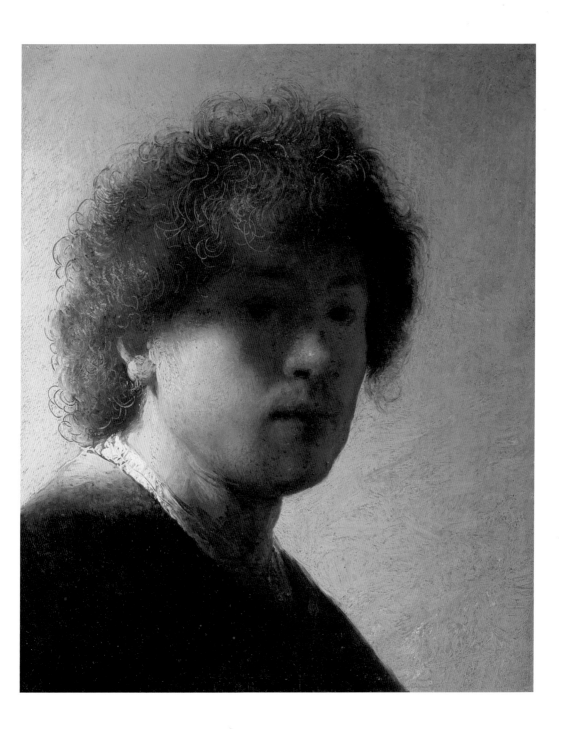

The Artist in His Studio

1628

Oil on wood, 25 x 31.5 cm
Boston, Museum of Fine Arts

Rembrandt's self-portraits often provide direct insight into his understanding of the role of the artist. Some of his portraits mirror the sometimes dramatic developments in his life. Entirely irrespective of their individual subject matter, whether drawn from mythology, history or Holy Scripture, Rembrandt's paintings show that for him painting was capable of eliciting a lively emotional involvement on the part of the viewer. Although it appears to depict a thoroughly mundane scene, some researchers see in the small work reproduced here not so much a self-portrait, but rather an allegorical representation of painting. The painter, who is clearly not very tall, stands in the background in a bare, unadorned studio. The plaster on the walls is stained and covered with cracks. The scene is dominated by the easel in the foreground, on which sits a large panel. Where the sunlight that illuminates the room diagonally from the left falls on the edge of the wood panel, the plaster gesso used as a primer is clearly visible. This detail is also interesting from a biographical point of view as Rembrandt actually did use mainly wood, rather than canvas, at that time. With a sure eye, Rembrandt chooses the moment when the painter confronts a still-empty canvas. In doing so, he focuses on the moment of creation within the mind of the artist as the significant event, and not the physical execution of the painting.

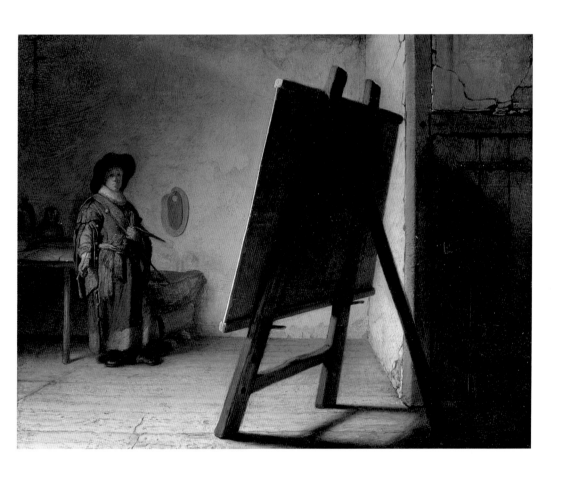

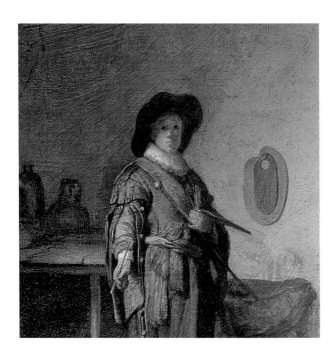

*The Artist in
His Studio (details)*

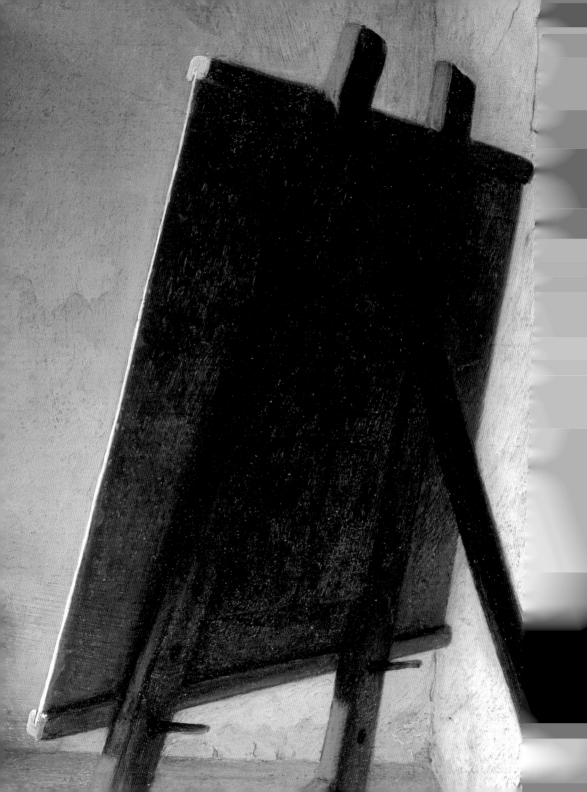

Jeremiah Lamenting the Destruction of Jerusalem

1630

Oil on canvas, 58 x 46 cm
Rijksmuseum, Amsterdam

Executed towards the end of Rembrandt's first creative period, this painting is also a masterpiece in the style of the so-called *Leidse Fijnschilders*, the "fine painters of Leiden." Its charm lies in the distinctive depiction of light, which suffuses each and every detail. The rendering of the goldsmith's work, which is spread out in the foreground at the lower left-hand edge of this small-format painting, and seems to catch the glow of the fire that is consuming the city, is remarkable.

The city burning in the distance is Jerusalem. The scene is taken from the Old Testament. It describes the lament of the prophet Jeremiah over the destruction of Jerusalem by Nebuchadnezzar, the king of Babylon. The Netherlands viewed its independence with pride. Simultaneously, however, the people were pious and god-fearing, and understood many biblical scenes to be indications of the fate of the young nation, whose religious and political struggle for freedom made the Netherlands, in the eyes of its citizens, a "new Israel." The elderly prophet has the features of Rembrandt's father, Harmen van Rijn, who was a humble miller. Rembrandt used members of his family as models for the biblical characters in his paintings on numerous occasions.

The Presentation of Jesus in the Temple

1631

Oil on wood, 61 x 48 cm
Mauritshuis, The Hague

Despite the relatively small format of the painting, its composition imbues it with monumental scope. Here, too, the young Rembrandt shows his predilection for striking compositions, from the grand architectural backdrop, via the large number of people depicted, to the expressive gestures of the main figures. Anybody unaware that paintings were not hung in the unadorned churches of Dutch Calvinists could take this to be a traditional altar painting.

In the perfection of the execution and the intellectual depth of its conception, this work marks an important moment in Rembrandt's artistic development. The composition contains elements and motifs to which Rembrandt would later return. One of these is his particular interest in ritual actions and events that take place in holy spaces. He returned to this motif repeatedly in his etchings and in his paintings. The individual interpretation of this theme is perhaps linked to Rembrandt's independence in religious matters. Although his work shows that he read the Bible very attentively, and with deep understanding, he retained his spiritual freedom and never explicitly affirmed any particular confession.

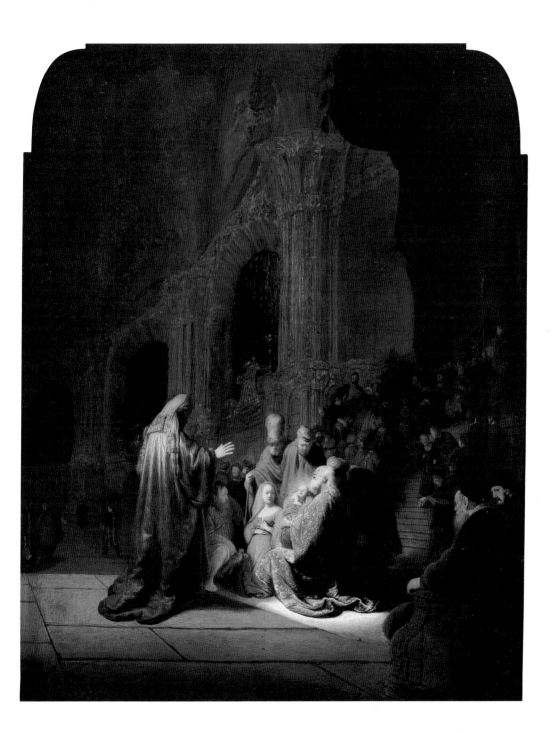

The Anatomy Lesson of Dr. Nicolaes Tulp

1632

Oil on wood, 169 x 216.5 cm
Mauritshuis, The Hague

That he was commissioned to paint a group portrait intended to embellish the assembly hall of Amsterdam's surgeons' guild shows just how quickly Rembrandt, who was only twenty-six years old at the time, made a name for himself as a painter among the city's upper classes after his arrival from Leiden. Confidently, the artist followed the custom of the great masters of the Italian Renaissance in signing the painting with only his given name, not adding his patronymic, Harmenszoon, nor his surname, van Rijn. Harking back to Dutch painting traditions, this work shows the public lecture on the anatomy of the hand given by the well-known Amsterdam physician Nicolaes Tulp in January 1632. Tulp, the first specialist in anatomy in the local surgeons' guild, enjoyed such a reputation in his field that he was described as the Dutch equivalent to Andreas Vesalius, the founder of modern anatomy. The dissections, carried out yearly before an audience, were recorded in several group portraits by other artists. Rembrandt himself returned to this genre much later in his career, when he painted *The Anatomy Lesson of Dr. Deyman* (1656), showing the latter in the process of examining a brain (the fragments of the painting still in existence are today in the Amsterdam Historical Museum).

The seven members of the audience gathered around Dr. Tulp's dissection table are not physicians but magistrates, and their names are recorded in a list that one of them holds in his hand. The name of the man whose body was selected after execution, is recorded too. The painting expresses equal amounts of scientific curiosity and a certain revulsion. Tulp is carrying out a dissection of the tendons in the hand, whose function he is demonstrating with his left hand, which is free. As the anatomical precision of the depiction proves, Rembrandt had detailed knowledge of the human body, which Leonardo da Vinci had long before demanded every artist should have. Rembrandt stayed in contact with Dr. Tulp's family for many years. Tulp's daugher Margaretha married the businessman, art collector and poet Jan Six, who was among Rembrandt's closest friends and patrons.

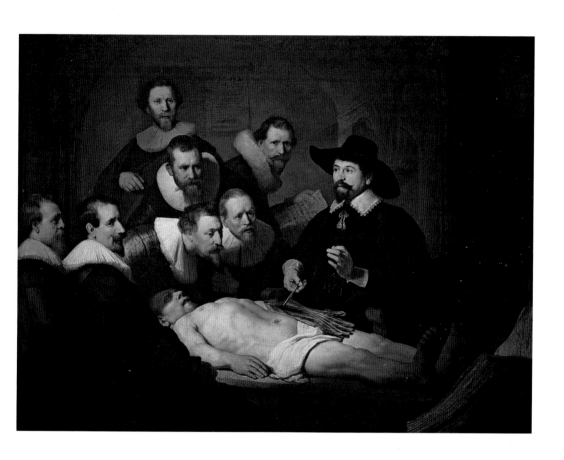

*The Anatomy Lesson
of Dr. Nicolaes Tulp
(details)*

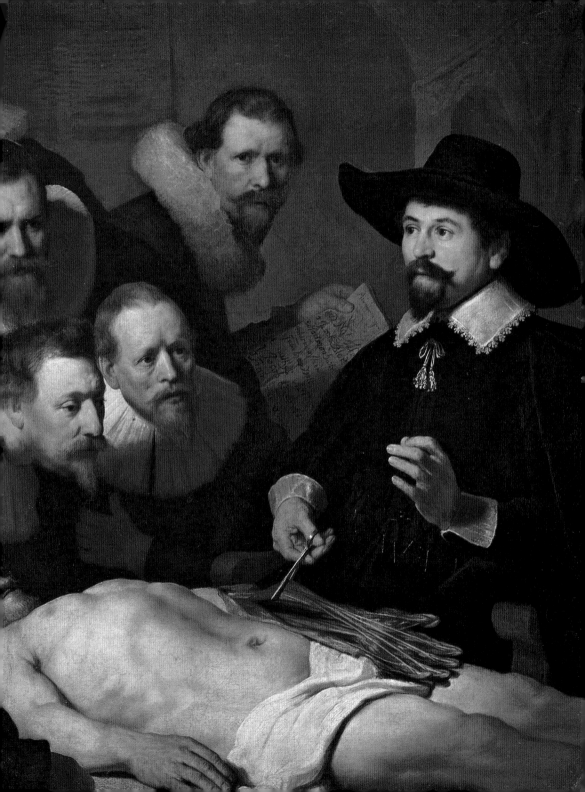

Saskia as Flora

1634

Oil on wood, 125 x 105 cm
The State Hermitage Museum, St. Petersburg

In the 1630s, Saskia van Uylenburgh, whom Rembrandt married on 22 July 1634, became his favorite model. A whole series of drawings, etchings, and paintings mirror their shared history. A drawing of the young bride, lost in thought and wearing a straw hat, for example, speaks of the tender love of their engagement. Periods of married bliss can be read into Rembrandt's work, as can the arrival of illness and death, to which Saskia succumbed in June 1642. Here, Rembrandt depicts Saskia as Flora, the ancient Roman goddess of spring and fertility, wearing a crown of blossoms and holding a scepter interwoven with tendrils. The symbolism, the posture, and the wide, puffy gown in which she is depicted could indicate that she is pregnant. Rembrandt's first son, who was given the name Rumbertus, was born in 1635. Like the two girls born after him, both of whom were named Cornelia in memory of Rembrandt's mother, he died just a few weeks after birth. Only Rembrandt's son Titus, born in 1641, reached adulthood. This portrait is among the most glorious works of Dutch painting, and makes direct reference to Titian and to Venetian art of the 16th century. Its competition with the spectacular compositions of Peter Paul Rubens and his school in nearby Antwerp is just as obvious, as evidenced by the figure positioned dominantly in the middle of the composition, her long, flowing hair, and the opulent flower arrangements.

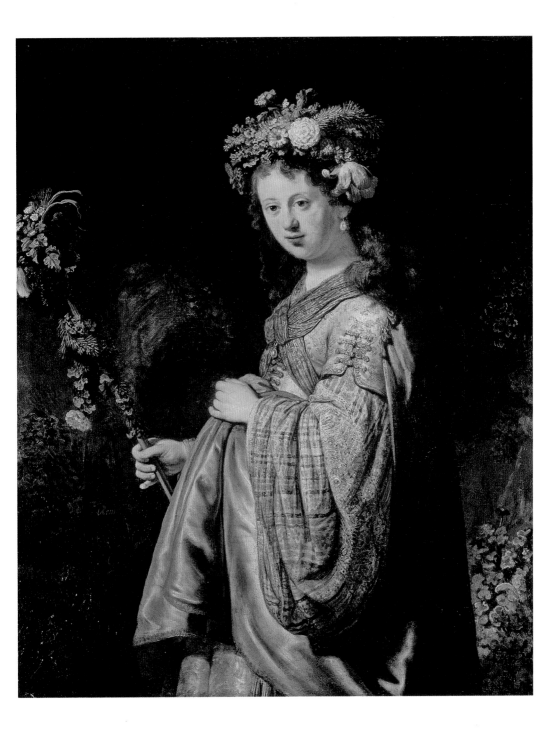

Artemisia (Sophonisba Receiving the Poisoned Cup)

1634

Oil on canvas, 142 x 153 cm
Museo del Prado, Madrid

It is not possible to identify unequivocally the female figure who sits majestically at the center of this painting, adorned with pearls and holding her hand over the seam of her richly embroidered brocade robe. It may be Artemisia, the widow of King Mausolus, at the moment when she is handed a valuable goblet holding a drink made of the ashes of her dead husband. It may, on the other hand, represent Sophonisba, wife of Massinissa, King of Numidia, preparing to drink from the poisoned cup that is to prevent her from being captured by the Romans. The question of who is depicted in this painting has also been answered with reference to a number of other tragic female characters from antiquity. The identity of Rembrandt's model, on the other hand, is no mystery. The hint of a double chin and the long, red-blond hair reveal that this is his wife, Saskia. In this large-format work, Rembrandt clearly attempts a comparison with the female figures in the paintings of Titian and Rubens. He presents himself as an artist in no doubt of his success among art collectors and as a painter whose talents were recognized far beyond the boundaries of his own country.

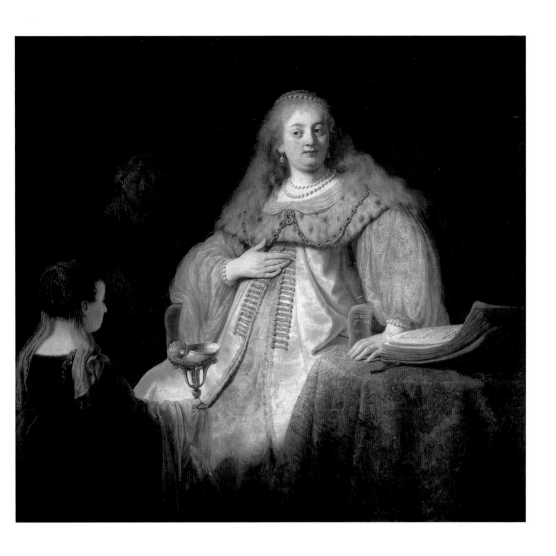

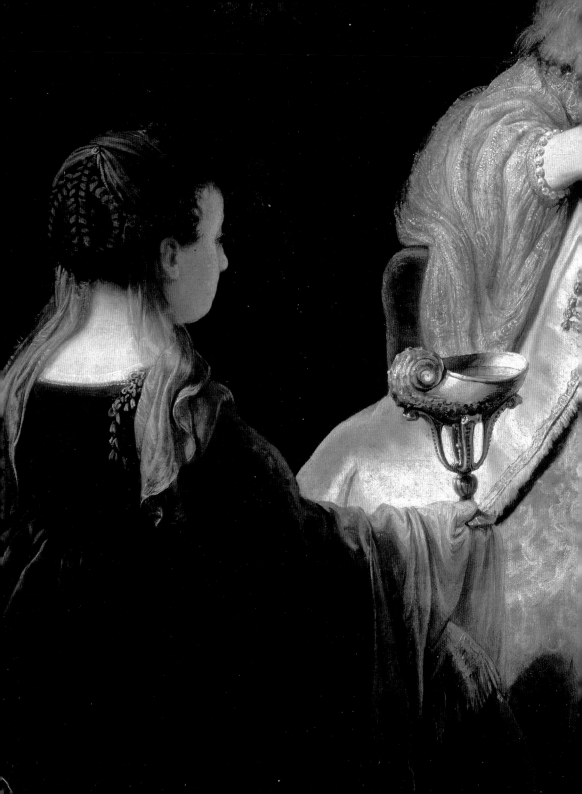

Belshazzar's Feast

c. 1635

Oil on canvas, 167.5 x 209 cm
National Gallery, London

The period between 1630 and 1642 represents the highpoint of Rembrandt's career. Artistically, the competition between him and Peter Paul Rubens, who worked in nearby Antwerp, was particularly stimulating. Rembrandt also drew on subjects, formats and compositions from the Venetian painting traditions of the 16th century, from Titian and Veronese to Tintoretto. The paintings of this period are rich in light and color. The figures appear lifelike and are often shown wearing exotic costumes. In this painting, Rembrandt depicts the Babylonian king Belshazzar at the feast. The holy vessels that his father Nebuchadnezzar had looted from the temple in Jerusalem when he deported the people of Israel are spread out in front of Belshazzar. During the climax of the feast, mysterious writing appears on the wall of the chamber. This is interpreted by the summoned prophet Daniel as the announcement of the imminent downfall of Belshazzar and his rule. For the Hebrew inscription "Mene mene tekel upharsin," Rembrandt took guidance from the Torah scholar Menasse ben Israel, a member of the Jewish community of Amsterdam, which was flourishing at that time. Despite the fact that Rembrandt is far from restrained in the expressiveness of the gestures and looks, the wide-open eyes, and the hands frozen mid-movement, or in the details of Oriental luxuriance, he is successful in capturing a moment of dramatic movement in a very memorable way.

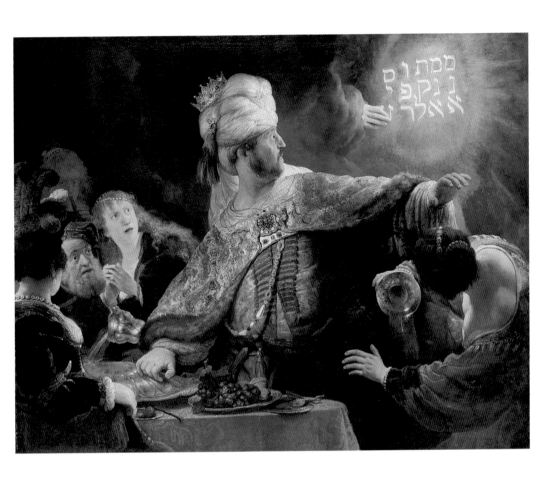

Belshazzar's Feast
(details)

The Sacrifice of Isaac

1635

Oil on canvas, 193 x 133 cm
The State Hermitage Museum, St. Petersburg

At a time when he was a sought-after portraitist who gathered a steadily growing circle of pupils around him, Rembrandt also painted his biggest and most magnificent historical painting. This depicts the dreadful moment when Abraham is preparing to sacrifice his son Isaac in obedience to God. In an act of pitying humanity, he covers Isaac's face with his hand so that the boy does not have to witness the deed. Other artists had already produced well-known paintings on the same subject, and Rembrandt is consciously presenting his version for comparison with corresponding works by Caravaggio, artists of the Italian Renaissance, and those of the Flemish Baroque. Rembrandt himself never traveled beyond the borders of his native land. Nonetheless, thanks to the widely available copper engravings of famous paintings, and the lively trade in artworks throughout Europe, which also flourished in Amsterdam, he was well-informed about both the recent history of art and its latest developments.

In addition there were his extensive activities as a collector of paintings, drawings, exotic objects, and scientific and other rarities of all kinds. Even in the 1630s, which can be described as the happiest period in Rembrandt's life, his careless treatment of the family fortunes gave rise to criticism. There was even a legal battle with his wife Sakia's family, who feared that he would eventually squander her considerable dowry if he continued to purchase expensive collector's pieces with such abandon. Rembrandt's collection also included a series of valuable oriental weapons. One of them served him as a model for the sacrificial knife which Abraham drops at the last moment.

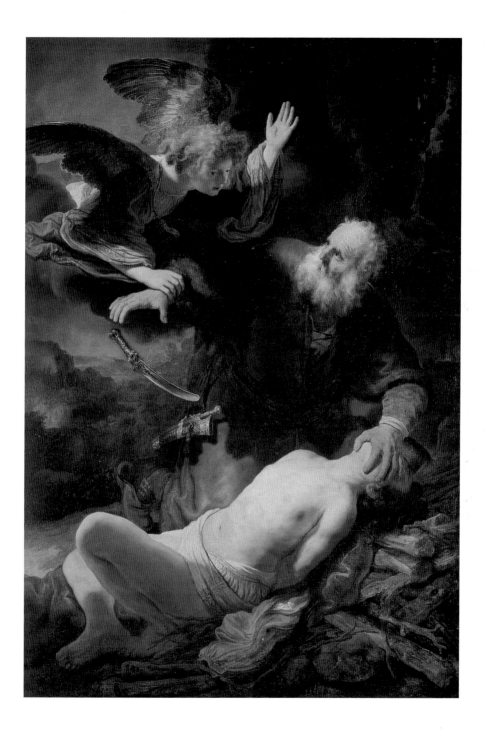

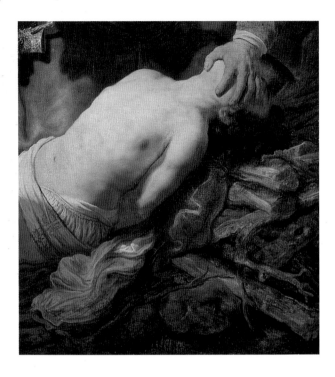

*The Sacrifice
of Isaac
(details)*

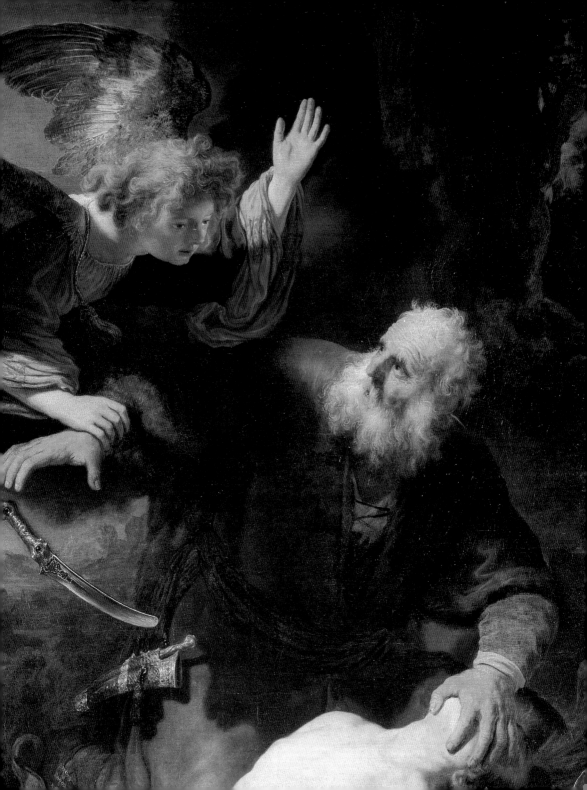

Self-Portrait with Saskia (or The Prodigal Son with a Whore)

c. 1636

Oil on canvas, 161 x 131 cm
Gemäldegalerie, Dresden

A wealthy marriage, and a considerable income not only from his portraits and etchings but also from his growing number of pupils, made Rembrandt a prosperous man by his early thirties. He established contacts with the upper-class circles of Amsterdam society and moved into a new house on the banks of the River Amstel. There he devoted himself to his expensive passion for collecting and rented a warehouse that also served as artist's studio and as accomodation for his paying pupils.

At the height of his success, the artist presents himself to the viewer in a very unusual self-portrait. Full of *joie-de-vivre* and in the best of moods, he sits at a richly laid table, his wife Saskia on his knees, and raises his glass to the viewer in a toast. Rembrandt illustrates the words from the Parable of the Prodigal Son, in which it states that a young man squandered his entire fortune with "riotous living." However, in this painting, which radiates a love of life, there is little evidence of the threatening fall from grace and moral censure for extravagance. Even if Rembrandt already moved in upper-class circles at this point, he did not hesitate to portray himself in a situation which betrays his humble origins and his down-to-earth preferences. Saskia on the other hand, who had been well brought-up, seems more restrained and almost embarrassed.

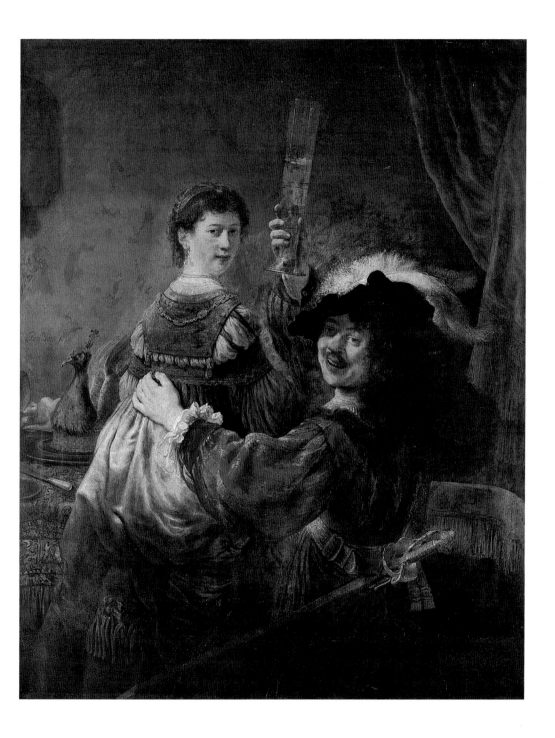

Landscape with a Stone Bridge

1636

Oil on wood, 29.5 x 42.3 cm
Rijksmuseum, Amsterdam

Pastures and fields beside water, tranquil meadows, deserted buildings, windmills, and bridges are the dominant motifs of Rembrandt's landscapes. The light falling diagonally draws the contours of objects and flickers in the trees and leaves while in the sky dark clouds pass by; the scene is pervaded by a gentle melancholy. Although landscape painting occupies only a modest part of Rembrandt's oeuvre (about a dozen pictures of this genre are considered with certainty to have been painted by him), they nonetheless represent a part of his work which should certainly not be neglected. They show his deep affinity with the countryside and nature of his Dutch homeland. All who wish to understand the spirit which pervades Rembrandt's paintings must not ignore his deep roots in the culture of the Netherlands and in its distinctive way of seeing the world. Thus, for example, Henri Focillon wrote: "What would Rembrandt be without Holland? He was a son of Holland, and he remains Holland's king. The cities and landscapes which surrounded his life were not the ones his compatriot [Frans] Post sought in Brazil, nor were they— despite the similarities—the day-after-the-storm depicted by Hercules Segher, or the romantic Norway of [Allaert van] Everdingen, and [Jacob Isaackszoon van] Ruysdael. *Six's Bridge*, the *View of Omval near Amsterdam*, the *Windmill*, the *Three Trees*, are also portraits of a kind. Even more so are the many other sketches, etchings, and drawings which breathe a gentle literalness, the affection of a soul which is receptive to all the things which surround it. If Rembrandt is in a position to shed light on their unexpected identity with a single line, a shadow, a light accent, sometimes simply a dot, then it is because links exist between him and the things which no mere chance and no momentary analysis can create."

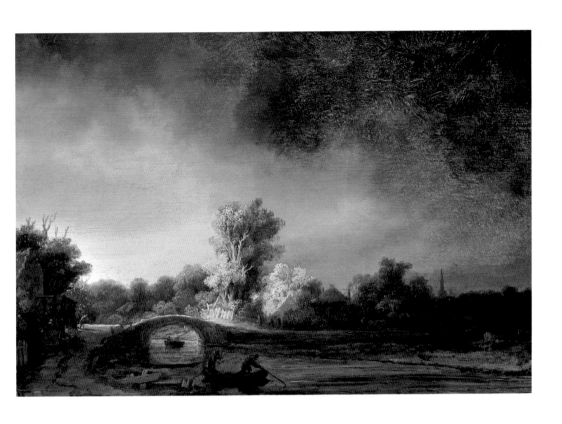

*Landscape with
a Stone Bridge
(details)*

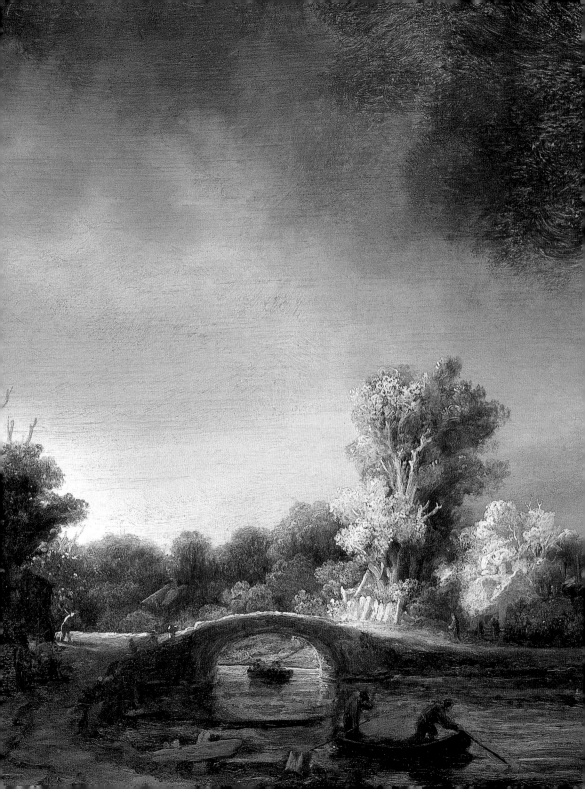

The Blinding of Samson

1636

Oil on canvas, 236 x 302 cm
Städelsches Kunstinstitut, Frankfurt

This picture is filled with drama and violence like no other painting in Rembrandt's oevre. It portrays the moment when Samson, one of the most powerful heroic figures of the Old Testament, is being held down and blinded. In the background, Delilah, who has cut off the unsuspecting man's hair while he was sleeping, thus robbing him of his strength, is holding his hair aloft. In this disturbing scene a loosely linked series of paintings on biblical champions reaches its climax. The painting was destined for an important recipient; it was evidently this picture that Rembrandt gave to the famous scholar Constantijn Huygens as a token of his gratitude, for he had supported Rembrandt's cause at the royal court in The Hague. In a letter of January 1639, Rembrandt informed Huygens: "Since your lordship has already taken the trouble for the second time in this matter, I am enclosing, as a sign of my respect, a work ten feet wide and eight high which is worthy of adorning your lordship's house." Huygens was the man who first discovered Rembrandt's talent. He had known him since his years in Leiden and had followed his development. It was he, too, who recommended him to the governor of the Netherlands, Frederik Hendrik Prince of Orange, who thereupon commissioned Rembrandt to paint a series of five pictures representing the Passion of Christ. Huygens knew and valued the art of Italy—another reason why Rembrandt allowed himself to undertake a large-format, emotion-laden composition strongly inspired by the animated dynamics and the raking, diagonal light of Caravaggio.

Dead Peacocks

c. 1638

Oil on canvas, 145 x 135.5 cm
Rijksmuseum, Amsterdam

Rembrandt included a wide variety of themes, genres, and formats in his work. Still-life painting represents an exception which was clearly not one of his preferences and to which he only very seldom turned his attention. This applies not only to his paintings but also to his etchings, despite the fact that still lifes were extremely popular on the art market in the Netherlands in 17th-century.

Here a little girl is gazing solemnly from the semi-darkness at two freshly killed peacocks in the brightly lit foreground. Fresh blood is dripping from the dead birds' necks. Their plumage looks so realistic that one could almost touch it. Just as realistic in their materiality are the other objects: a fruit basket woven from willow, a wooden table, a stone lintel, wooden window shutters, and iron window bolts and hinge. Very effective, too, is the impression of depth in the composition. Above all, however, Rembrandt is presenting here a very individual reflection on death and the transience of all beauty. To understand this it is not even necessary to have recourse to the particular significance of the peacock as a traditional symbol of immortality, because before the introduction of the turkey, peacocks were extensively kept as ordinary poultry for slaughter throughout Europe. This still life was created at a time when decisive events were shaping in Rembrandt's personal life. In May 1639, the artist acquired the large house on Breestraat, incurring a debt that would eventually lead to his financial ruin.

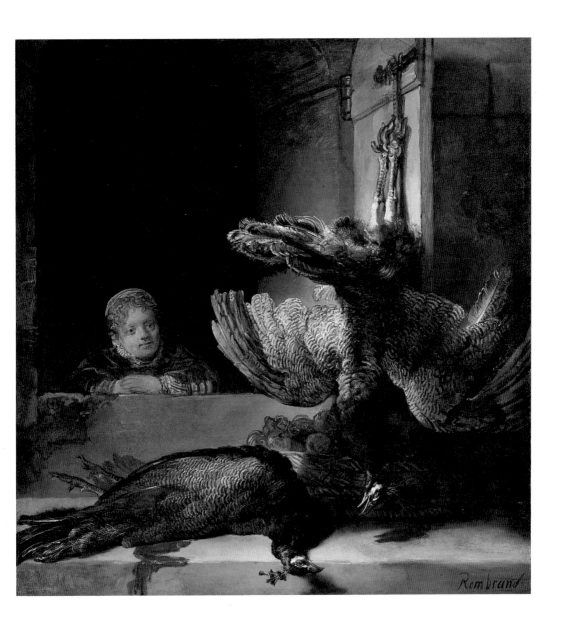

Dead Peacocks
(details)

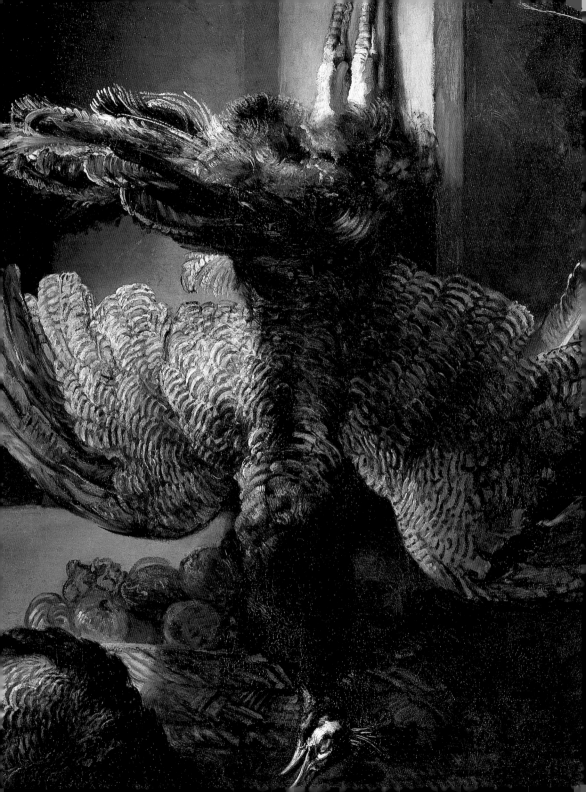

Self-Portrait at the Age of Thirty-Four

1640

Oil on canvas, 100 x 80 cm
National Gallery, London

At the height of his success, Rembrandt painted his likeness based on Raphael's portrait of the Italian humanist Baldassare Castiglione (1514–1515, Louvre). Raphael's painting was auctioned in Amsterdam on 9 May 1639. Rembrandt was among the bidders at the auction, which was held by the art dealer Lucas van Uffelen. However, at the dizzy bid of 3,800 guilders Rembrandt had to admit defeat, and the painting was acquired by the art and diamond merchant Alfonso Lopez. One compensation was that Rembrandt apparently had the opportunity to study Raphael's painting in detail, as this self-portrait, now on view in London, clearly shows.

Rembrandt transposes himself into the elegant, cultivated world of the Italian High Renaissance. The large velvet cap on which a golden chain gleams, the dark, fur-trimmed coat, and the frilled shirt lend the man in the portrait a cool elegance which was fitting in every way for Raphael's sitter, the author of *The Book of the Courtier* (1528), a guide to correct behavior at court that was read throughout Europe.

Cornelis Anslo and His Wife

1641

Oil on canvas, 176 x 210 cm
Gemäldegalerie, Berlin

Cornelis Claeszoon Anslo was one of the most eloquent preachers in the Netherlands. Although he was a member of the small society of Mennonites, who represented a moderate version of Anabaptism, members of other confessions also valued his skills as a speaker. In a four-line poem the well-known Dutch poet Joost van den Vondel demanded that Rembrandt "paint Anslo's voice"—for those who wished really to get to know Anslo had to hear him speak, since his visible physiognomy permitted one to recognize only the smallest part of his being. Rembrandt took up the challenge. Indeed, the portrayal of Anslo's appearance accounts for only part of the effect of the painting. The comparison with preliminary drawings and an etching shows how in the painting the figure of the preacher retreats into the background, while at the same time the composition acquires certain additional features.

The work is one of the liveliest and most penetrating "portraits of a human voice" in the history of painting. The mouth, opened to speak, the gesture which accompanies the words of the preacher, the expression of pious emotion on the face of the woman, probably his wife, and finally the supernatural light which fills the scene—all this seems to confirm the words of Joost van den Vondel. And the books and the candelabra, which lie side by side in the brightest part of the picture, have not been chosen at random: they refer to the enlightening power and depth of knowledge which are concealed in the written word and especially in the Holy Scriptures. Their deliberate juxtaposition is a clear sign that here the idea of "enlightenment" is being presented symbolically.

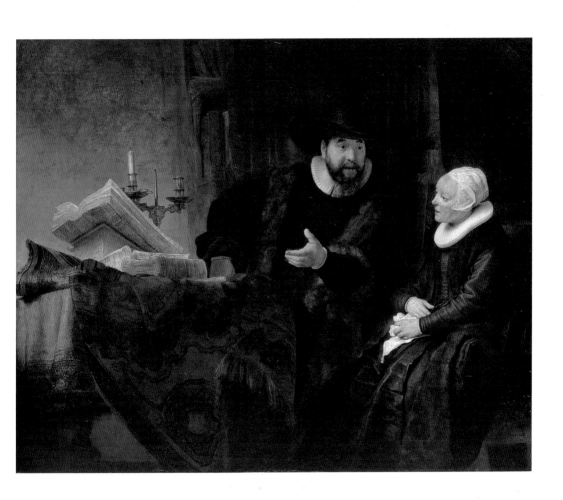

David Taking Leave of Jonathan

1642

Oil on wood, 73 x 61.5 cm
The State Hermitage Museum, St. Petersburg

Rembrandt repeatedly turned his attention to a series of biblical topics and figures, such as Tobias, Samson, King David, and the Prodigal Son. In doing so he often developed new picture solutions for these subjects, or took up subjects which at that point had never or only seldom been treated in art. In some cases, therefore, it cannot be ascertained with certainty which scene is being portrayed. This is also true here. Instead of the leave-taking from his friend Jonathan, some experts see in this painting David's reconciliation with his son Absalom. Although Rembrandt played no part in the social life of the Calvinist community of his native town—a fact at which some of his fellow-citizens took umbrage—he nevertheless developed a very profound and personal understanding of the Holy Scriptures. He not infrequently incorporated his own experiences and feelings into the portrayal of a biblical scene and identified with the figures involved. In the moving embrace of the two figures in this picture is reflected Rembrandt's leave-taking from his wife Saskia, who had died of consumption on 14 June 1642, the same year that it was painted. After her body had been temporarily buried, Rembrandt had it transferred to a burial place in the left transept of the Oude Kerk (Old Church) on 9 July. Twenty years later he had to sell the expensive burial place in the city's main church, and Saskia's mortal remains were moved for a second time, on 27 October 1662, this time to the recently built Westerkerk (West Church). Rembrandt himself was also laid to rest in this great Late Renaissance building designed by Hendrick de Keyzer and completed in 1631.

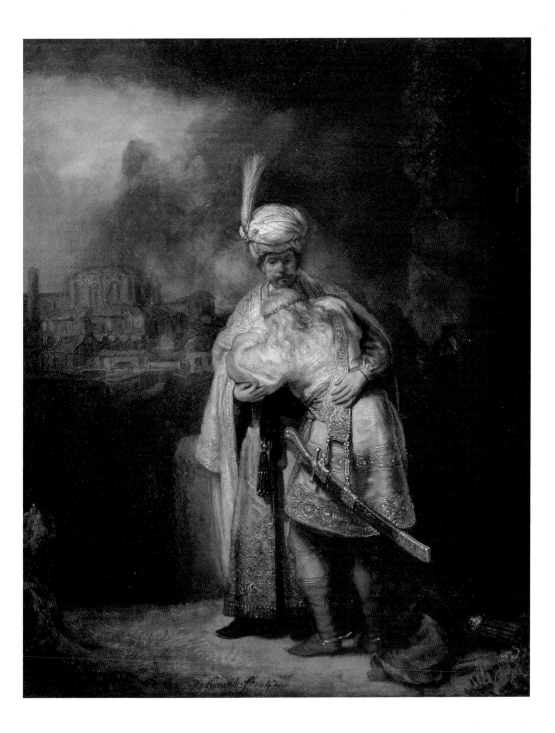

The Night Watch (The Company of Frans Banning Cocq)

1642

Oil on canvas, 359 x 438 cm
Rijksmuseum, Amsterdam

The painting, commissioned in 1640 for the ceremonial hall of a citizens' militia, and completed in 1642, is Rembrandt's largest painting to have survived. In 1715 it was hung in the New Town Hall, today's Royal Palace; during Napoleon's reign it was moved to the Trippenhuis, which was then a science and arts institute; and it eventually found its way to the Rijksmuseum in Amsterdam, where it remains the highlight to the present day. It is now common knowledge that the title "The Night Watch" is misleading; the event portrayed, a company of militiamen setting off, takes place in daytime. The command to do so is issued by Captain Frans Banningh Cocq, who can be seen in the foreground. Gesturing with his left hand he commands his lieutenant, Willem van Ruytenburgh, to get his disorderly troop of men to fall in. The captain's hand casts a distinct shadow on Ruytenburgh's uniform jacket, proof that the scene takes place in broad daylight. The dark background can be largely ascribed to the darkening of the layers of paint and varnish in some sections of the painting. The company is assembled on the square in front of the main entrance to their assembly rooms, on the steps of which the figures are informally arranged on three descending levels.

According to the contract, Rembrandt received 1,600 guilders for the commission; each of the sixteen members of the company paid a varying amount, depending on their position in the picture. In fact, almost twice as many people are depicted: there are a total of twenty-eight men (plus three children), and not all of them can be allocated to a rank within the troop. Rembrandt, who was personally never a member of one of the volunteer militias formed for the defense of Amsterdam, gives his picture a hint of irony by portraying the company as an array of not very martial-looking men who clearly have difficulty handling the awkward implements of war. Like a secret observer between the standard-bearer and the man with the helmet to his right, the painter himself appears in the painting, studying the scene over the shoulders of the men standing in front of him.

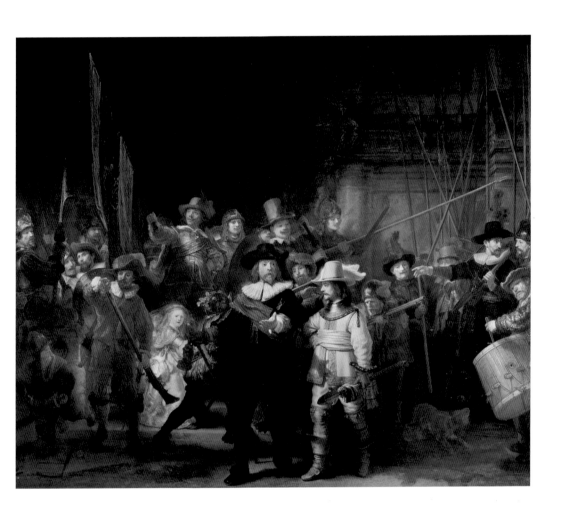

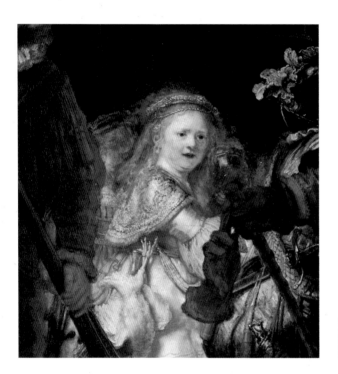

*The Night Watch
(The Company of
Frans Banning Cocq)
(details)*

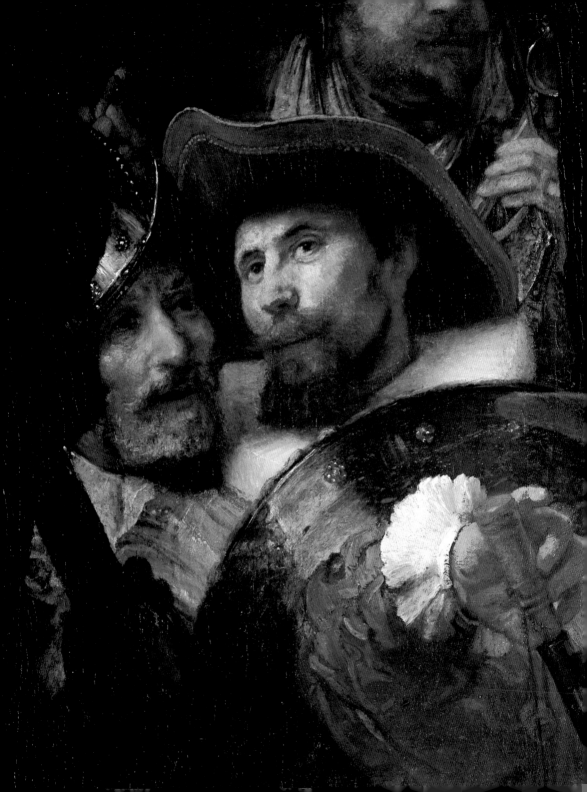

The Woman Taken in Adultery

1644

Oil on wood, 84 x 65.5 cm
National Gallery, London

Although modest in dimensions, the painting conveys a monumental impression of space. The massive pillars bearing the vaulting of the temple are lost in darkness and give a feeling of the vast size of the chamber. We can almost sense Rembrandt's regret that he never had the opportunity to compare his work with the great altarpieces of the Renaissance and the Baroque. This painting showing Jesus and the woman taken in adultery represents the transition between two phases in Rembrandt's artistic career. On the one hand we recognize here, in the fine lines of the figure drawing and the precise use of light, characteristics of his early work, which includes the use of wood as a picture ground. And on the other, the arrangement of the group of figures and the monumentality of the picture space, which gives the effect of a stage cloaked in darkness, pave the way for subjects which Rembrandt would take up again many years later in *The Conspiracy of Claudius Civilis* (1661, Nationalmuseum, Stockholm). Thematically this painting marks the beginning of a phase in Rembrandt's work in which female figures often form the main focus of attention. Here it is the adulteress, whom Jesus preserved from the wrath of the angry crowd, according to St. John's Gospel (7:53–8:11), with the words: "Let he who is without sin cast the first stone!"

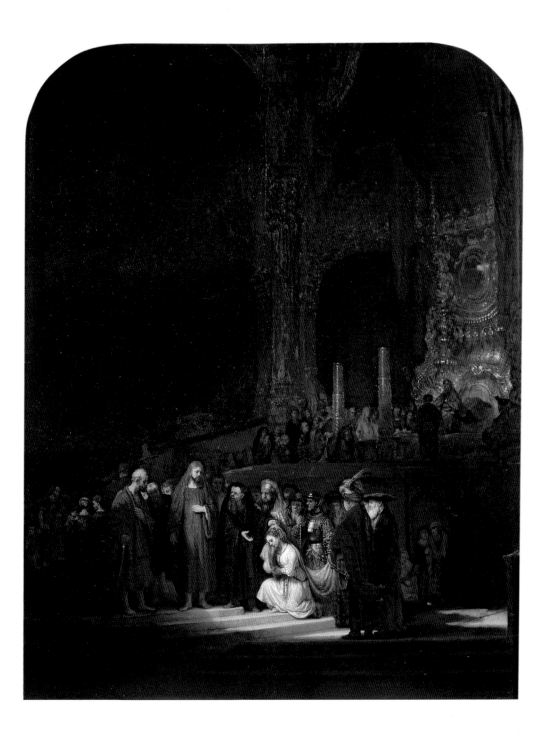

Holy Family with Angels

1645

Oil on canvas, 117 x 91 cm
The State Hermitage Museum, St. Petersburg

This homely domestic scene is one of a whole series of representations of the childhood of Jesus produced by Rembrandt, which incidentally reflect his great affection for his only son, Titus. In this work, too, instead of the finely worked details and bright, clear light of his early work, we find more diffuse tones and blurred contours. Of note is the figure of St. Joseph, who is modestly going about his work as a carpenter in the background, who thereby also acquires a special dignity (here we can suspect a memory on Rembrandt's part of his own childhood as the son of a simple miller in Leiden). Despite all the touching tenderness in the scene, however, the viewer nonetheless senses that there is a certain anxiety, even sadness. Mary looks apprehensively at the child in the cradle, and the cherubs, descending from above and hovering, do not look joyful; one of them spreads his wings as if presaging the crucifixion. Here, again, there seem to be echoes of the difficult domestic situation in the Rembrandt household, where after Saskia's death Geertje Dircx took care of little Titus and would soon become Rembrandt's problematic mistress.

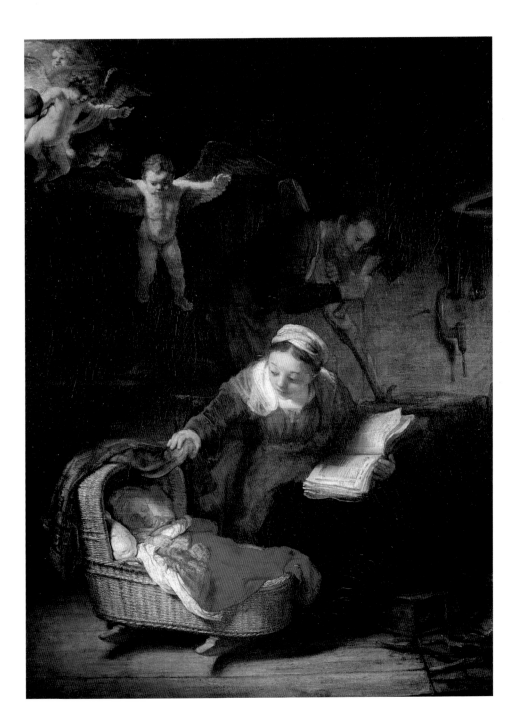

A Woman in Bed

1645

Oil on canvas, 81 x 67 cm
National Gallery of Scotland, Edinburgh

The picture probably shows a biblical scene: Sarah is waiting on her wedding night for her bridegroom, Tobias, who first has to offer up a sacrifice to avert a deadly curse. Even more interesting than the choice of this rarely portrayed biblical subject is Rembrandt's sensitive portrayal of female emotions. Rembrandt depicted women sensitively, but without idealizing them or making them ethereal; they remain women of flesh and blood. In contrast to the tender bonds of love which linked him and his wife Saskia, the relationships which developed after her death were of a more sensuous and passionate nature. This, however, did not alter the great fascination which Rembrandt felt for the world of women, young or old. As in virtually no other artist of his age, we encounter repeatedly in Rembrandt's work over a long period sensitive portraits of women, little girls, enchanting adolescents and young ladies, mothers surrounded by their families, buxom wenches, and old women who, though fragile, still have an alert look in their eyes.

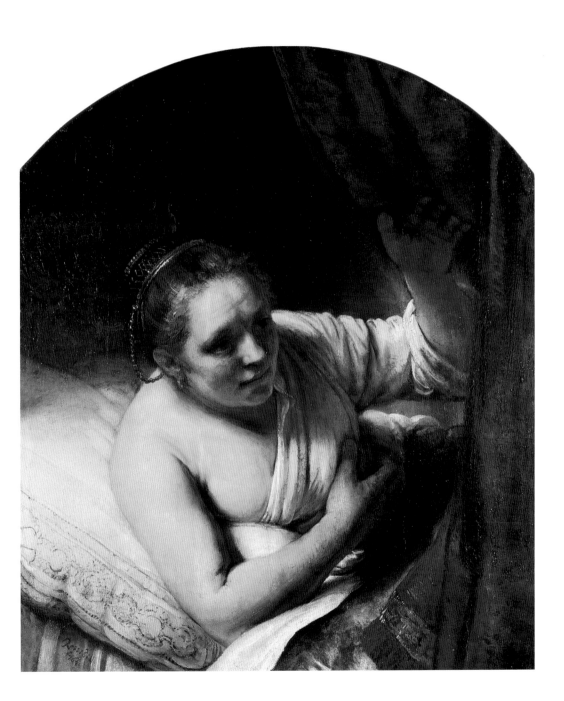

Holy Family with a Curtain

1645

Oil on wood, 46.5 x 68.8 cm
Staaliche Kunstsammlungen, Kassel

This painting represents an exception in Rembrandt's work, since he here used the trompe-l'œil technique which was very popular at the time. The impression is created that we are looking at an elaborately carved frame, in front of which a heavy curtain which has only been half-pulled to one side is hanging from a rod. Behind that our gaze falls on the actual scene, a "picture within a picture." It shows the Holy Family in the semi-darkness of evening. Mary is sitting beside the fire with the Baby Jesus; in the background we can make out St. Joseph at his workbench. In the center foreground, near the fire, crouches a clearly well-fed cat, the symbol of domestic peace and family happiness. The scene is perhaps an expression of the artist's longing for peace and emotional security. For Rembrandt must have felt the painful contrast between this idyll and the reality of his own life. When he painted it, he was still suffering from the shock of the death of his beloved wife, Saskia. She had died after the birth of their son, Titus, who henceforth became the object of all Rembrandt's affection. Beyond the artifice aimed at deceiving the eye, Rembrandt has here succeeded in giving the domestic scene of maternal love an intense mood through the thick application of paint.

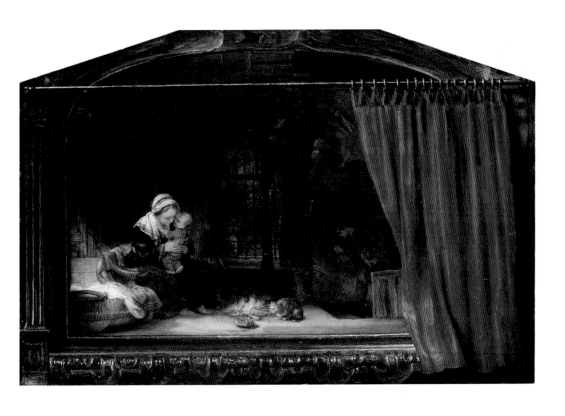

Self-Portrait

1652

Oil on canvas, 112 x 81.5 cm
Kunsthistorisches Museum, Vienna

After the death of his wife Saskia, Rembrandt initially concentrated above all on the art of etching. This self-portrait was produced some years later. This time he is not wearing a splendid costume as in earlier self-portraits, but faces the viewer in simple working clothes. This appearance corresponds with the image of an unconventional artist who lived on the fringes of elegant society, a man with perhaps somewhat boorish manners and a neglected appearance, but also a deep awareness of the dignity of painting. In 1686 the Florentine art writer Filippo Baldinucci recorded a widely held view of Rembrandt during his lifetime: "Since this painter had his own ideas regarding his attitude to his appearance and was unlike other people, he was also exceptionally unusual in his way of painting and created a style which we can describe as entirely his own. It consisted of painting without contours and without lines on the inside or out, using only energetic, repeated brushstrokes ... Rembrandt's way of life was in complete harmony with his extravagant painting approach. His speech was always full of mockery and he despised everyone else. His ugly and plebian face was accompanied by dirty clothes as it was his habit when working to wipe his brushes on himself. But when he was busy he would have refused to give an audience even to the most powerful ruler in the world."

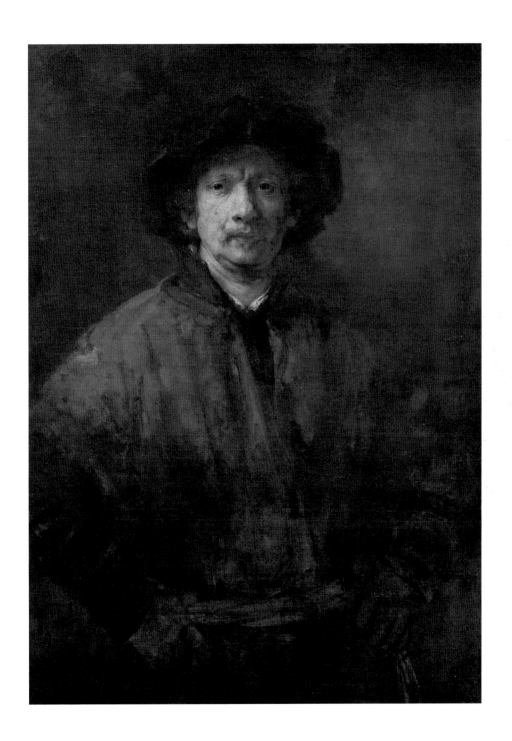

Aristotle with a Bust of Homer

1653

Oil on canvas, 143.5 x 136.5 cm
The Metropolitan Museum of Art, New York

The commission for this painting came from the nobleman Antonio Ruffo from Messina, who was the most important collector of Rembrandt's works in Italy during the artist's lifetime. The subject—the philosopher Aristotle contemplating a bust of the poet Homer—might have offered the opportunity to design a classical setting with antique-style robes and replete with learned allusions, but Rembrandt produced nothing of the kind. His picture conjures up the power of memory and records an encounter beyond historical fact. The bearded Aristotle is wearing a billowing, gleaming white tunic under an intensely black over-garment, across which shimmers the glistening gold of a long chain. In the shadow of a broad-brimmed hat the philosopher's features glow with experience of life. His determined expression speaks of inner emotion. The proximity of the two great men of antiquity is movingly expressed in the gesture of trust with which Aristotle places his hand on the head of the bust of the oldest and most venerable of all Greek poets. As if by a miracle, it seems as though the marble of the sculpture is starting to come to life at this touch. Across the centuries, Rembrandt uses his skills as an artist to make the viewer into a witness of a silent dialogue which reaches into the present day. At the sight of this picture, the Sicilian Antonio Ruffo may have been reminded of Dante, who on his journey into the next world meets Aristotle, the "Master of all Knowledge," and Homer, the "Prince of Poets."

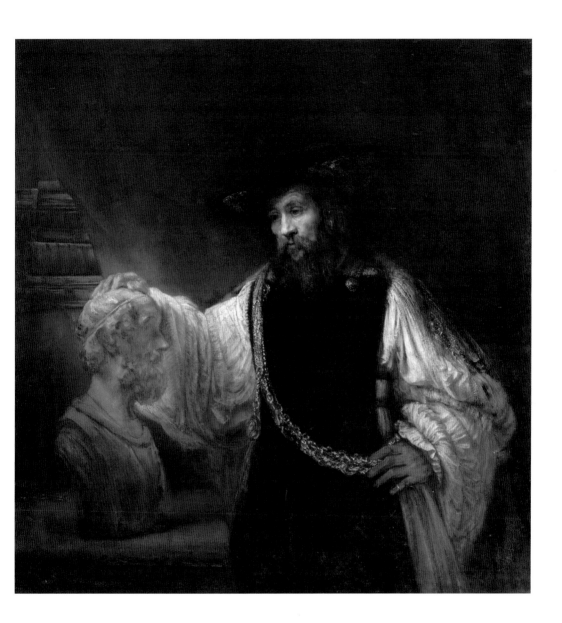

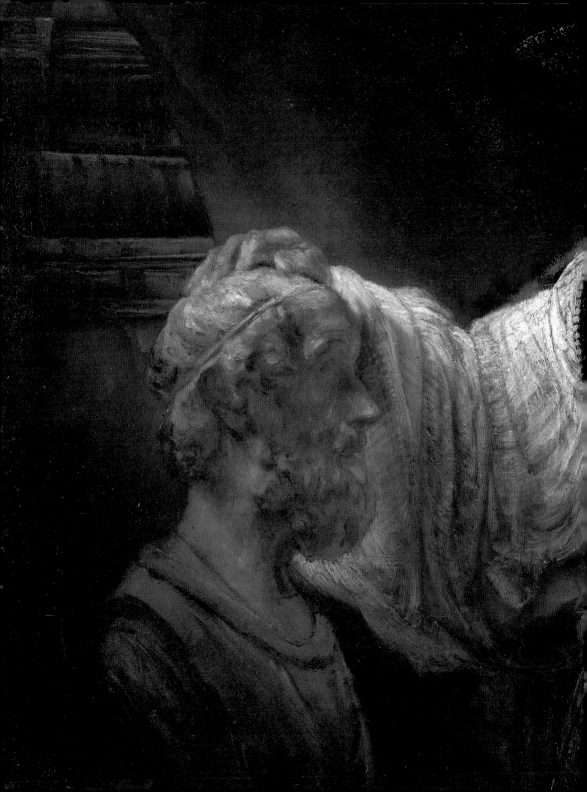

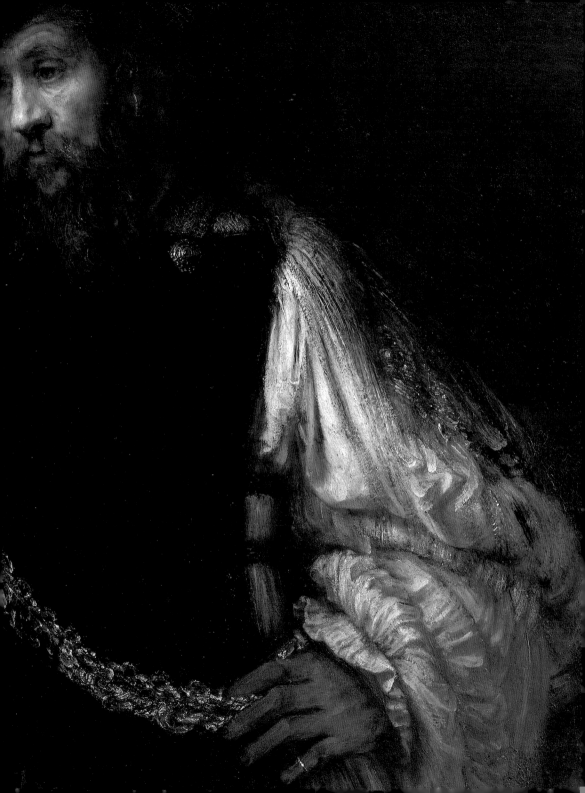

Portrait of Jan Six

1654

Oil on canvas, 112 x 102 cm
The Six Collection, Amsterdam

Jan Six became one of the most significant people in Rembrandt's later years. The poet and author of tragedies was an important member of upper-class society in Amsterdam, whose mayor he later became. Rembrandt had painted his portrait several times, initially in a number of etchings and finally in this unusual painting. In the difficult years after Saskia's death, Six was Rembrandt's closest friend. He was always sensitive and discreet, though the two men had very different backgrounds socially and biographically. Six was a wealthy man and was generous in helping the painter, whose financial situation deteriorated steadily, with advances and loans, even though it was by no means certain that they would be repaid. Rembrandt created a permanent memorial to their friendship in this painting, which many consider to be his best portrait. Six was a man who was in the public eye, always busy, always in a hurry. He had little time to sit as a model for his artist friend. So Rembrandt shows him, in contrast to the usual style for portraits of this type, on the move, about to leave. Still wearing his hat, a bright-red coat with golden braid over his shoulder, Six is just pulling on a glove. Since he is painting the picture of a friend and connoisseur, Rembrandt could allow himself to paint in a dynamic and powerful sketch-like manner, especially as regards the clothing. He applied the paint in thick layers with summary, freely placed brushstrokes, so that in some places it is raised from the canvas almost three-dimensionally (a technique similar to that used a century earlier by Titian in his *Portrait of Pietro Aretino*, 1545, Galleria Palatina, Florence). At the same time, Rembrandt, with acute psychological insight, captures the character of his friend, who, despite the courteous maintenance of good form, reveals an expression between nervous haste and embarrassment as he pulls on his glove before setting off.

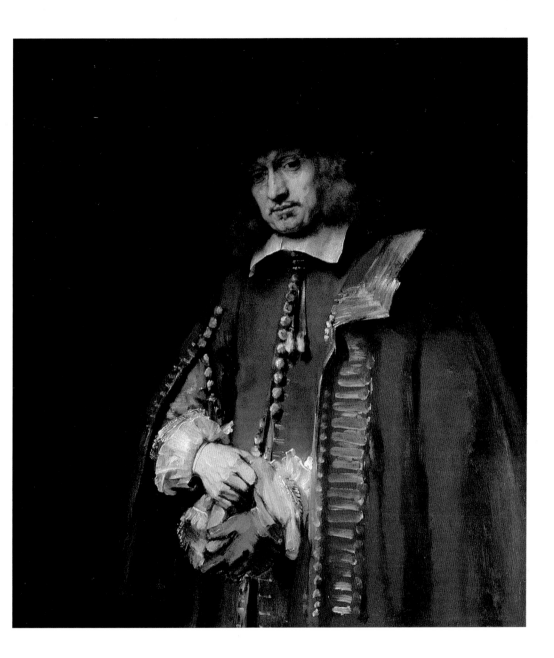

A Woman Bathing in a Stream (Hendrickje Stoffels?)

1654

Oil on wood, 67 x 54 cm
National Gallery, London

Dutch painters during the 17th century produced a number of very sensitive portraits of
women; we need only think of Johannes Vermeer. Rembrandt, too, sometimes adopted
these quiet moods, though he usually turned his attention to the sensuous side of the fe-
male psyche. He created women of flesh and blood rather than delicate creatures who
seem to be from another world. He shared his preference for sensuous and ample fe-
male figures with Titian, whose work remained an important stylistic point of reference
for Rembrandt throughout his life, and also with the fellow northerner Peter Paul
Rubens. If we look back on Rembrandt's life, he apparently succumbed increasingly to
this predilection after the death of his wife, Saskia. Within the modest dimensions of this
painting he has portrayed with rapid, in some places dense, brushstrokes a young
woman bathing in a stream. She has hitched up her tunic as far as her hips and is look-
ing with a smile at her reflection in the water. The contrast to the demure housewives
presented in so many paintings by Dutch painters of this period could hardly be greater.
There is no concrete proof to substantiate the conjecture that the young woman is
Hendrijke Stoffels, with whom Rembrandt had lived together since the end of the 1640s.

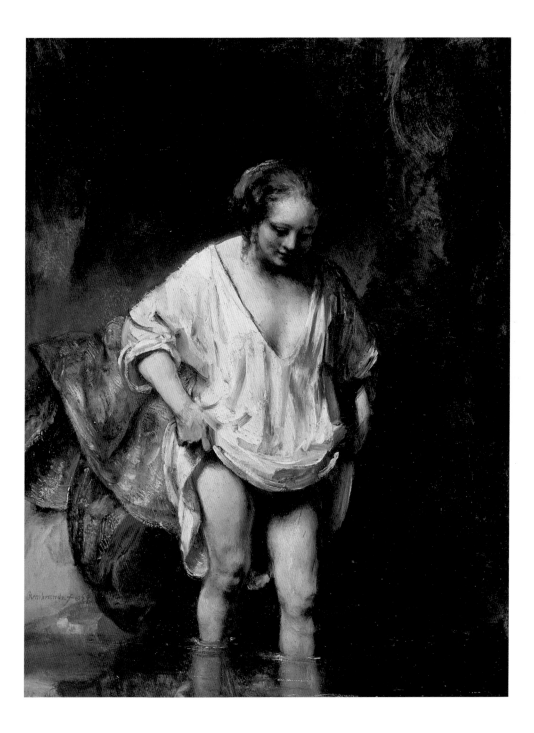

The Slaughtered Ox

c. 1655

Oil on wood, 94 x 67 cm
Musée du Louvre, Paris

Rembrandt had already painted a slaughtered ox once before, some seventeen years previously (c. 1638, Glasgow Museums and Art Galleries), but it is only here that the urgency of his interpretation of the subject comes into its own. The unvarnished directness of the picture has inspired other painters, especially during the 20th century, notably Pablo Picasso, Chiam Soutine, and Francis Bacon. It seems as if the artist, who was inescapably heading towards financial ruin, identified with the fate of the vanquished beast, yet without a hint of self-pity. The scene is plunged in a gloomy semi-darkness. As if hanging from a bloodstained torture apparatus, the disemboweled body of the dead ox radiates in its forlornness a dignity and power which demands respect. Unlike many of his Dutch colleagues, Rembrandt painted very few still lifes. He produced no complex and conventional Vanitas allegories with skulls, guttering candles, or sand running away from broken hourglasses. He preferred to consider the questions of death and transience by studying dead animals, freshly killed hunting quarry, and slaughtered cattle. Into this category fall his first *Slaughtered Ox*, the *Hunter with Bittern* (1639, Gemaldegalerie, Dresden) in which a man's face (perhaps Rembrandt's) glows behind the dead bird, and the picture of a little girl gazing earnestly at two dead peacocks whose blood is running from their necks (c. 1638, *Dead Peacocks*, Rijksmuseum, Amsterdam). The girl hurrying through the crowd of people in Rembrandt's *The Night Watch* is also carrying dead birds at her belt. And yet the tragic depths of the myths of antiquity are reached only in the *Slaughtered Ox*, which recalls Titian's late painting the *Flaying of Marsyas* (c. 1575, Archiepiscopal Palace, Kromeriz).

Jacob Blessing the Sons of Joseph

1656

Oil on canvas, 175.5 x 210.5 cm
Gemäldegalerie, Kassel

The large-format picture of Jacob's blessing deserves close attention, not only because of its experimental painting style but also because of the unusual choice of subject. Here Rembrandt has once again chosen a biblical event that had seldom been portrayed by artists in order to give it an individual interpretation. The scene refers to the chapter in the First Book of Moses (Genesis) which relates how the patriarch Jacob blessed the descendants of his son, Joseph, whom the latter has brought to the old man's deathbed. However, Jacob does not place his hand on the head of Manasseh, the first-born son, but first blesses the younger son, Ephraim, and thus makes him the chosen heir of the tribe. Joseph grasps anxiously but tenderly at his father's hand to place it on the head of little Manasseh. The older child watches helplessly as the blessing passes him by, while the chosen one, Ephraim, humbly bows his head at the touch. Asenath, Joseph's wife, solemnly watches the proceedings from the right of the picture. In the Bible story there is no mention of her at this point, but Rembrandt clearly felt that the presence of the mother of the two boys was essential.

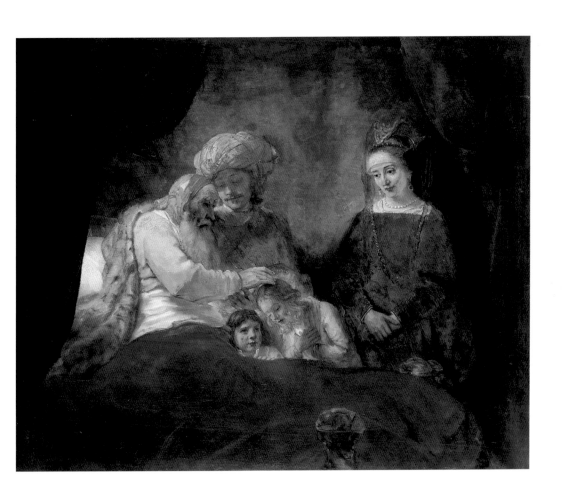

Hendrickje Stoffels (Young Girl at the Window)

1657

Oil on canvas, 88.5 x 67 cm
Gemäldegalerie, Berlin

This portrait was executed at a time when Rembrandt painted almost exclusively the people in his immediate vicinity. He portrayed his son Titus reading, relaxed, and with a smile on his face. He painted himself during this period with an expression of earnestness and concentration, but without any suggestion of worry. He also turned his attention as a painter to Hendrickje Stoffels, the woman who shared his life. She was a simple woman who could neither read nor write, but she was blessed with a good deal of common sense. She supported Rembrandt with courage and determination and helped him in practical ways, for example with the drawing up of the list of his possessions during the bankruptcy proceedings. Neither the gossip of the "respectable people" nor the public admonitions of the Calvinist community succeeded in deterring her. She would never be a woman from the upper echelons. But she was the calming influence in Rembrandt's life. And that is how he painted her, unshakeable in her composure, and yet sensuous and with female pride, standing at the window of the house where they lived on Breestraat, which she defended with such energy.

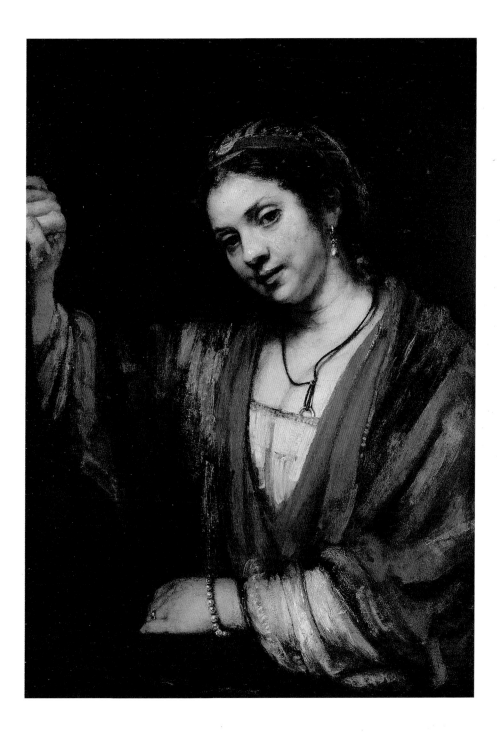

Titus Reading

c. 1657

Oil on canvas, 70.5 x 64 cm
Kunsthistorisches Museum, Vienna

After Saskia's death, Rembrandt's affection was concentrated entirely on their son, Titus. He painted him time and again: as a small child, as a boy, as a youth. The portraits of his son represent some of the most touching chapters in Rembrandt's oeuvre. They show a sensitive, intelligent young man whom Rembrandt portrays in a tender, sensitive manner. The father seems to observe him secretly in all the stages of his development, as if he is worried about the well-being of his only son, whom he loves more than anyone else on earth. The childhood portraits look as if Rembrandt was searching for the features of the boy's mother in his face, with its rosy cheeks and blond curls. While the fifty-year-old Rembrandt portrays himself in his self-portraits as an exhausted, almost laughable, old man, the youthful Titus on the verge of adulthood looks like an angelic figure, with his pale, transparent skin. A little prince with lively eyes and a winning smile, perhaps a little shy, but blessed with the same bright radiance as Saskia. Rembrandt was often criticized by his contemporaries for his dark, heavily applied colors—but when he painted Titus, his brush seems to have been dipped in light.

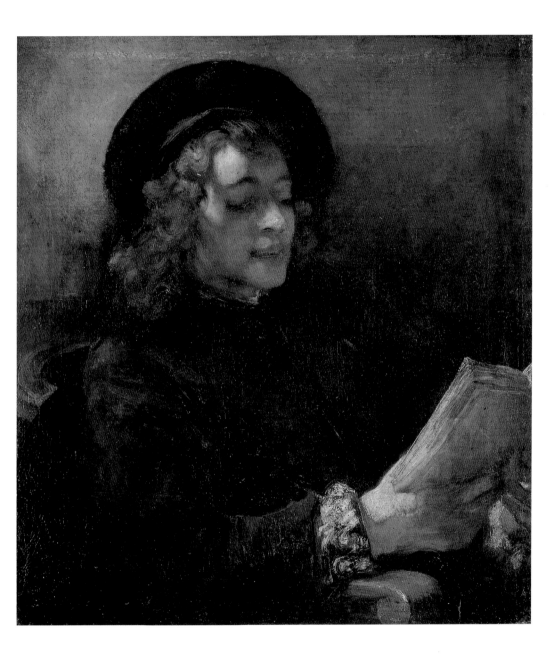

Self-Portrait

1658

Oil on canvas, 134 x 104 cm
The Frick Collection, New York

Rembrandt's livelihood became precarious. Money slipped through his fingers, friends turned away, clients became dissatisfied with his work, and his creditors demanded to be paid. Rembrandt would soon be forced to declare bankruptcy and auction his property. The self-portraits of these years show a man who ages visibly day by day, his face bloated, his hair gray, his beard thinning. His painterly brushstrokes became more powerful during this very period. In his painting, he had the quiet confidence and success absent from his personal and professional life. And so he created masterpieces of great forcefulness and impressive clarity. In this self-portrait from 1658, the painter faces us with total poise, holding in his left hand a cane that looks like a scepter symbolizing a power that could be described as transcendent. Wearing a golden jerkin whose neckline is richly decorated, he rests his arms on the armrests of his throne. The end of the red sash that has been carefully wound around his heavy-set waist is attached to a heavy gold pendant in the shape of a pine cone. A wide, fur-lined cloak covers his shoulders. Rembrandt's face, half-immersed in the shadow of a satin cap that melts into the dark background, looks fleshy and heavy. Marked by deep wrinkles, it is hardly recognizable as that of a fifty-year-old. And yet the subject of the painting exudes the full power and dignity of painting. This is despite the fact that at the time Rembrandt was witnessing the sale of his collection, his house, and his entire property.

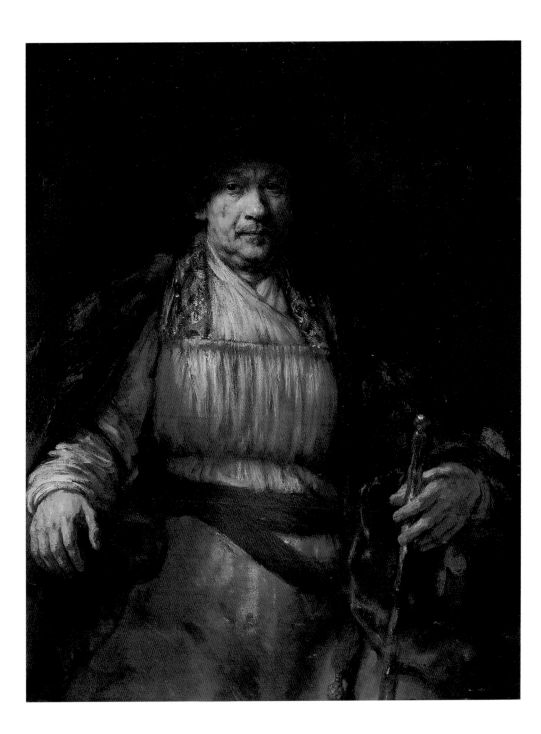

The Denial of Peter

1660

Oil on canvas, 154 x 169 cm
Rijksmuseum, Amsterdam

Rembrandt's later paintings, which are today considered to be among the most profound and moving in the history of art, were frequently met with incomprehension by his Dutch clients. At a time during which audiences began to look to a style characterized by fine lines and clear contours, he leaned towards an expressive, consciously sketchy painting style. His art increasingly achieved a universal dimension beyond the styles and fashions of painting and of the dominant classicism of the day. In this context, it is revealing to quote the assessment of a contemporary art connoisseur: André Félibien des Avaux, the secretary of the French envoy to Rome at the time. He was a great admirer of the French artist Nicolas Poussin and of neo-classicism, an art style clearly very far removed from what Rembrandt aimed for in his painting. Félibien does not hold back on the widespread criticism that the coarse Dutchman fell short when it came to the requisite adherence to the rules and essential gracefulness in great art. He does, however, also express how deeply impressed he is by the naturalness and power he finds in Rembrandt's paintings. In 1685, Félibien wrote: "All of his paintings are executed in a very personal way, which is quite different from the slick way Flemish painters usually lapse into, for he often limits himself to making rough brushstrokes, placing one color directly next to the other without bothering to combine or harmonize them. And yet, as people's tastes vary, a considerable number of people value his works very highly. Furthermore, he is possessed of great skill and has painted some beautiful heads. Even if these are not blessed with a gracefulness of the brush, they do have a great power, and if one looks at them from an appropriate distance, they make an excellent impression and appear to be quite three-dimensional and well formed."

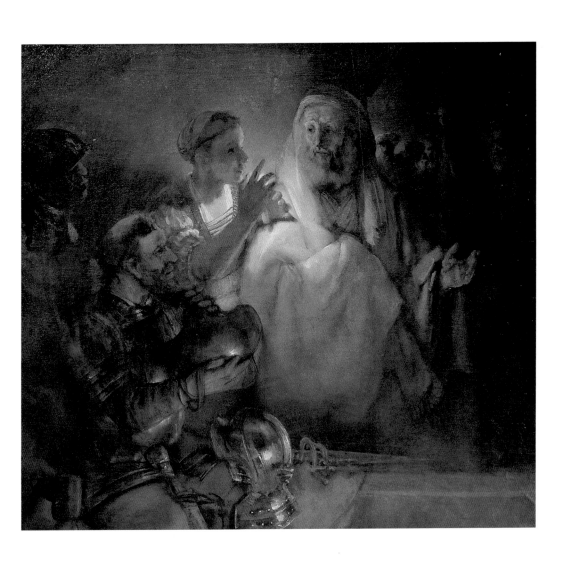

Portrait of Jacob Trip

c. 1661

Oil on canvas, 130.5 x 97 cm
National Gallery, London

Rembrandt presents the Amsterdam patrician Jacob Trip, head of a wealthy merchant family, as the noble representative of a vanishing species of hardworking, exceedingly successful businessmen completely lacking in personal pretensions. A glance at the painter's self-portrait in the Frick Collection, which shows him holding a cane in his hand (see page 117), reveals noticeable parallels, so that one can assume that he strongly identified with the sitter. Like the late Titian a century before, Rembrandt came to renounce fine-lined precision and the exact representation of all details, turning instead to a painting style characterized by the thick, full-bodied application of paint. Pictorial details are no longer depicted in full, but implied, thus gaining greater emotional power. The comparison of this painting with a portrait Nicolaes Maes had painted of Jacob Trip shortly beforehand (c. 1660, Museum of Fine Arts, Budapest) shows that Rembrandt did not give priority simply to capturing a likeness. Instead, he strove to give his subject the dignity and authority of a biblical prophet or patriarch, beyond the time and circumstances of the moment.

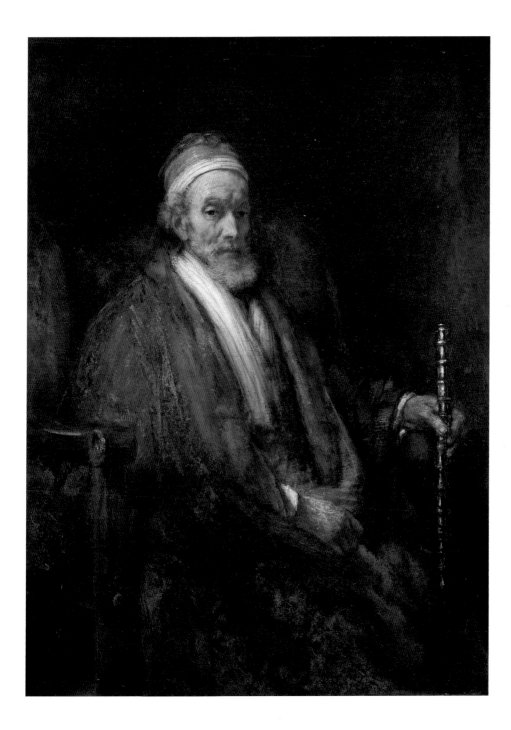

The Conspiracy of Claudius Civilis

1661

Oil on canvas, 196 x 309 cm
Nationalmuseum, Stockholm

Like the large-scale group portrait of the sampling officials of the drapers' guild (see page 125), the painting titled *The Conspiracy of Claudius Civilis* was commissioned by a public institution. The event depicted is from the early days of the history of the Netherlands, as described by Tacitus: the conspiracy of the Batavians against the Roman invaders, under the leadership of the one-eyed Julius (later also known as Claudius) Civilis. In its present state, the painting encompasses only the middle section of what was originally a much larger work. With a surface area of 36 square meters in total, it was more than double the size of *The Sampling Officials of the Drapers' Guild*, but Rembrandt himself later cut it down. The history of this work's creation is complicated. It was at first intended for Amsterdam's newly constructed Town Hall, and the commission was first awarded to Govaert Flinck, who presented a composition in the rather stiff neoclassical style that dominated the mid-17th century. After Flinck's death, Rembrandt was commissioned to execute the design. He completely ignored the existing sketches, however, creating instead a night-time scene that exudes the solemn atmosphere of a secret ritual. After the painting had been on view in the New Town Hall for a short time, it was taken down and sent back to Rembrandt, however. It was obviously not considered grand enough. It fell into oblivion until it was rediscovered in the 19th century, in the stores of Stockholm's Nationalmuseum.

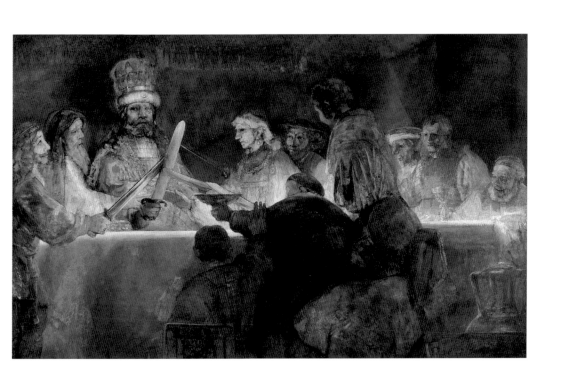

The Sampling Officials of the Drapers' Guild

1662

Oil on canvas, 191 x 279 cm
Rijksmuseum, Amsterdam

Rembrandt's disappointment over the rejection of his great painting for Amsterdam's New Town Hall was assuaged by a second public commission. The respected drapers' guild ordered a painting that would show the five sampling officials accompanied by their secretary. First, Rembrandt drew several individual portraits of the six subjects, and then arranged them in groups in order to create a lively dynamic between them and to give the painting a narrative element. The compositional focus of the scene is the guild's record book, which lies open on the table and around which the men's intent conversation appears to revolve. They stop talking just as the second man from the left gets up (thus interrupting the line of seated figures). One could describe Rembrandt's choice of an unusually low point of view as quite brilliant. At this precise moment, the six men focus their gazes and attention on the person opposite them. Rembrandt manages to involve the viewer to a degree that equals, or perhaps even surpasses, that achieved by Caravaggio. It is as though a sudden noise had betrayed the entrance of another person, making the drapers, hitherto immersed in conversation, look up from their book and fall silent. With an expression that lies somewhere between suspicion and expectation, six pairs of eyes are fixed steadfastly on the viewer.

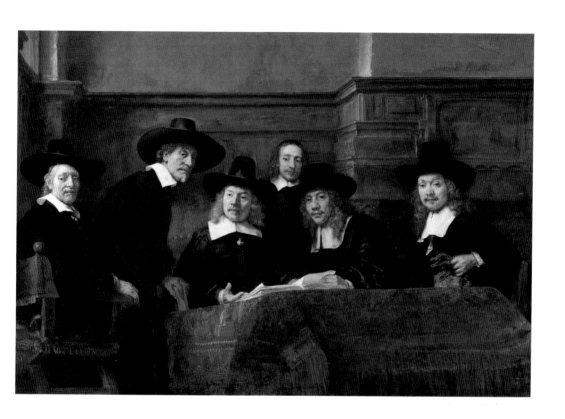

Self-Portrait with Two Circles

c. 1663

Oil on canvas, 114.3 x 95.2 cm
The Iveagh Bequest, Kenwood House, London

Rembrandt is approaching sixty years of age. The passage of time has left deep traces on his face, and he does not hide these from the viewer. The wiry fearnaught of the Leiden period has become a sedate old man. However, the same eyes, the eyes of a painter aware of himself and of his art, look out from under the heaviness of the contours. Compared to his early work, the painting style in particular has changed radically. Where once there were finely chiseled details, now there is a heavy, full-bodied application of paint that seems to radiate light.

Rembrandt stands in front of a blank wall, colored in light ocher, in his painting studio. Compared with the self-portraits of the previous years, the focal point has been shifted slightly further into the background. Behind the subject of the painting, one can make out two large circles. To this day, their meaning remains unknown. Are they simply proof of the artist's continued ability to carry out precise brushstrokes, mysterious symbols with a deeper meaning, or perhaps two terrestrial hemispheres in the manner of the Dutch sea charts of the period? However one interprets them, the painter stands firm and immovable between the two circles and, being the center of the composition, commands the entire pictorial space. He looks with composure towards the next chapters in a life that has been characterized by frequent calamities. In his left hand he holds the tools of his trade: palette, maulstick, and paintbrushes, which appear to melt into a single entity.

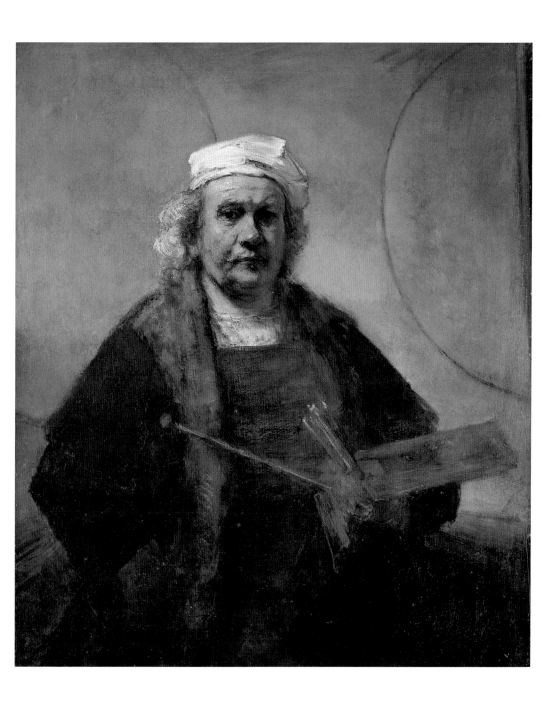

Family Group

c. 1667

Oil on canvas, 126 x 167 cm
Herzog Anton Ulrich Museum, Braunschweig

The fact that it has not yet been possible to identify the family depicted in this group por-
trait allows room for a tempting hypothesis. According to this theory, Rembrandt painted
this portrait of the ideals of marital and family bliss on the occasion of his son Titus's
wedding to Magdalena van Loo. As is often the case in Rembrandt's paintings, the
arrangement of the figures speaks a language that is unobtrusive and yet entirely clear.
The head of the family stands slightly in the background and observes the scene with a
smile (a client would hardly have allowed himself to be pushed out of the limelight in this
way). In front of him stand his two daughters. One of them is shown in profile, her hair
tied back, holding a basket (on whose rim the artist's signature can be discerned) of
flowers in front of herself. She appears to fully inhabit the role of the older, responsible
sister. Near her is the round face of the younger girl, an infectious, childish smile light-
ing up her face. The youngest child sits on her mother's lap, dressed, like her, in warm
red. In her small hand she holds a child's bell with a gold whistle and coral handle, fas-
tened to a chain around her neck. She appears not to know what to do with this toy, as
she is holding it the wrong way up. The tenderness between mother and child is shown
in a sensitive manner. The mother's attentive gaze rests upon the infant, which her slen-
der fingers hold carefully on her lap. The little girl rests her small hand on her mother's
breast, which is bare above the neckline of the dress.

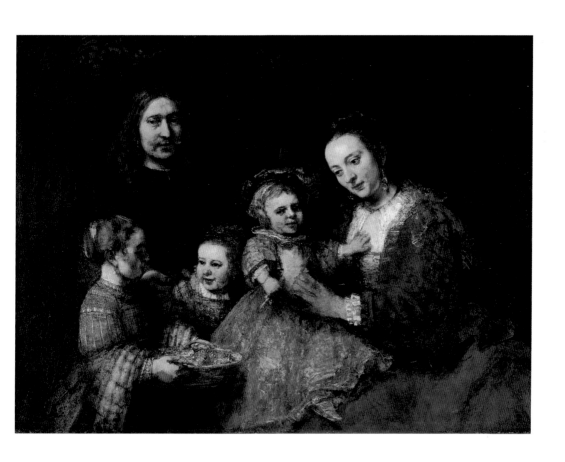

The Jewish Bride

c. 1667

*Oil on canvas, 121.5 x 155.5 cm
Rijksmuseum, Amsterdam*

As is the case with a number of Rembrandt's paintings, the title was not given by the painter himself. Here, the title is actually misleading, for the painting gives no indication that it represents a Jewish wedding (the couple's intimacy would, furthermore, hardly suit such an occasion). It belongs to the double-portrait genre, which was traditionally employed to commemorate weddings. The first of these portraits of couples go back to the Renaissance in Italy and to Frans Hals in the Netherlands. It has not yet been possible to identify the two subjects of this portrait. One suggestion has been that Rembrandt painted this work as a memorial to his son Titus's engagement to his bride Magdalena van Loo. A delicate interplay of interlaced gestures and glances between the man and the woman governs the painting's composition. From the point of view of technique, it is characterized by the dense application of color, which is in some places so thick that one can assume that Rembrandt worked on these areas with a spatula. The delicate interplay of the hands in particular is accentuated by the plasticity of the paint. The colors not only reflect the light that falls on the figures, they also create the appearance of the tangibility of material presence. The difference between the ways in which the faces and the robes are handled makes it quite clear that this was not as a result of diminished sight or an unsteady hand, but that Rembrandt made a conscious artistic decision to use paint in this physical way.

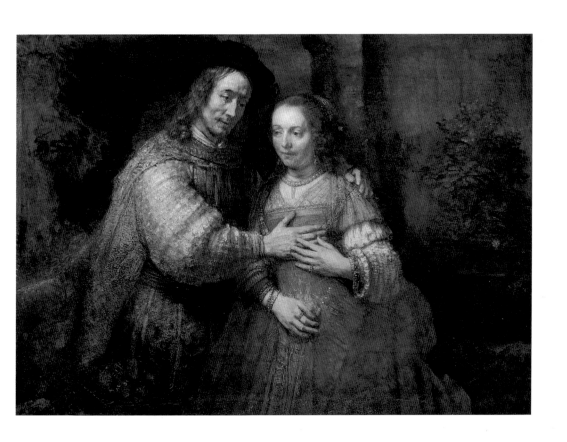

The Return of the Prodigal Son

c. 1668

Oil on canvas, 262 x 206 cm
The State Hermitage Museum, St. Petersburg

During the last year of his life, Rembrandt had to endure a great calamity. Just seven months after the wedding, his deeply beloved son Titus died. Magdalena, his wife, was three months pregnant. Once again, Rembrandt's life seems to be mirrored in one of his paintings.

The Return of the Prodigal Son is the last large-format oil painting by Rembrandt. He takes on the biblical subject with harrowing forcefulness. Father and son have almost melted into a single block in an act of affection simultaneously physical and emotional. An unbridgeable chasm separates father and son from those around them, whose body language and looks express coldness and incomprehension. The old father is bent over the maltreated body of his returning son as though he wants to both embrace and protect him. Exhausted, the son, so emaciated that he has become unrecognizable and physically disfigured, seems to abandon himself to his father's warming embrace.

The red of the cloak that covers the father's shoulders stands in contrast to the light-brown rags wrapped around the son. The cloak also envelops the couple and lifts them out of the darkness into which the background sinks.

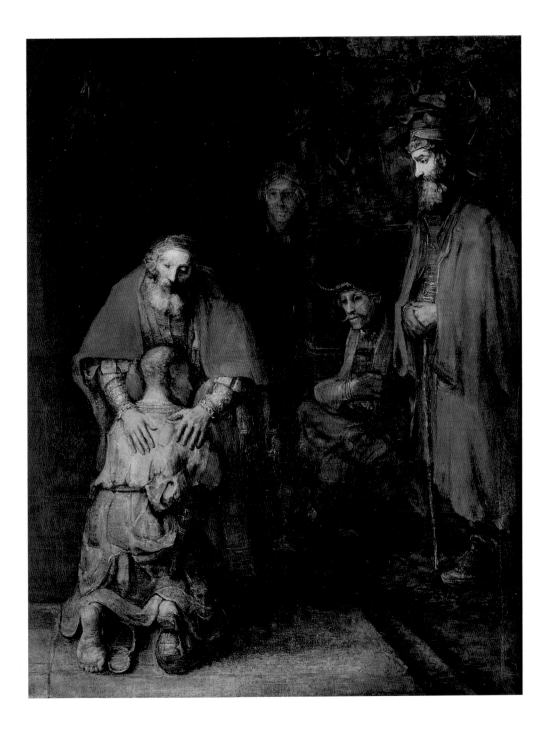

Self-Portrait

1669

Oil on canvas, 59 x 51 cm
Mauritshuis, The Hague

This painting is also known as the "Last Self-Portrait." The quotation marks that usually accompany this alternative title refer to the fact that there is a second self-portrait, in the collection of the National Gallery in London, showing the painter in an unusual pose with folded hands, which is also dated to the year 1669. It is impossible to ascertain which of the two is the last painting Rembrandt made of himself. The signs of exhaustion are even more clearly visible in the portrait in The Hague than in the London painting, however. Rembrandt makes use of very simple means here, and perfects the painting style of his last years as an artist, a style that is both rough and sketch-like, and simultaneously highly expressive. Loneliness and poverty governed his life at the house on Rozengracht to which he was forced to move following his bankruptcy. His late self-portraits are deeply personal records, freed of any pose or affectation of a man at the threshold: the last brushstrokes of an artist who vividly transformed the experiences of a long, intense, extraordinary life into painting.

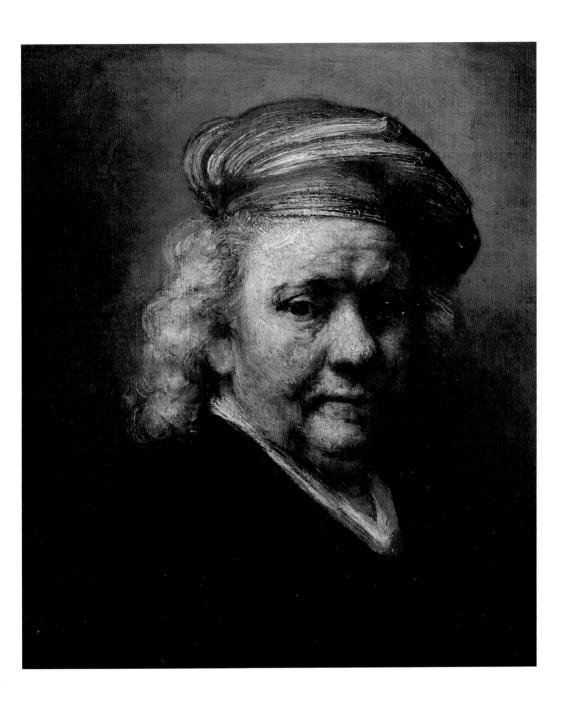

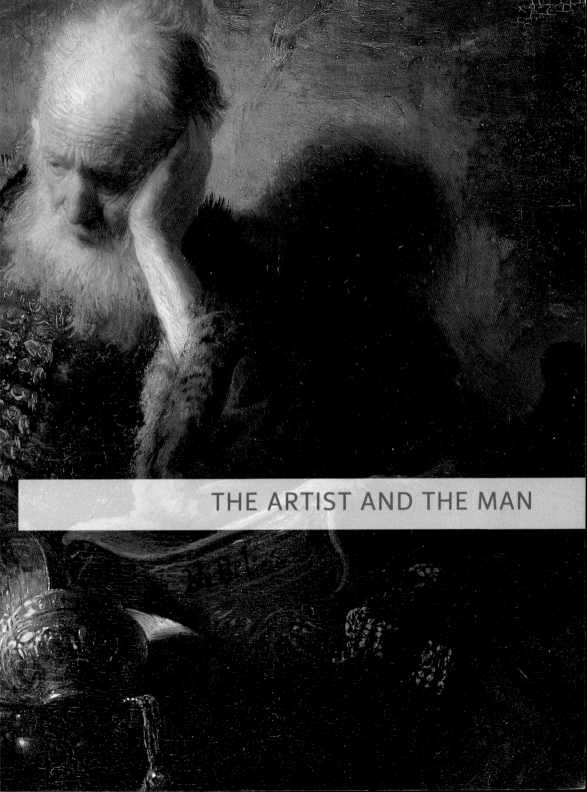

THE ARTIST AND THE MAN

Rembrandt in Close-Up

The Passion Cycle

"Most Gracious Lord Huygens, I should like to request that you, Sir, should inform His Excellency that I am working most diligently on the completion of the three Passion pictures which His Excellency himself charged me to paint: An Entombment of Christ, a Resurrection, and an Ascension of Christ; the same belong to the Raising of the Cross and the Deposition from the Cross."

Thus begins the first of seven letters which Rembrandt wrote to Constantijn Huygens between February 1636 and February 1639 and which almost exclusively describe the progress of his work on the so-called Passion Cycle. These letters to the influential diplomat, scholar and connoisseur of art from Amsterdam, who had discovered and encouraged the young Rembrandt while he was still in Leiden, represent the only longer texts by Rembrandt that we possess. The cycle of paintings had been commissioned through the good offices of Huygens by Prince Frederik Hendrik of Orange, the *stadtholder*, or governor, of the United Provinces of the Netherlands. Since the state was Calvinist, altar and devotional pictures were not permitted, so this commission provided Rembrandt with a rare opportunity to paint large-format religious scenes of the type usually produced as altar paintings. However, the execution proved more difficult and arduous than expected due to requests for changes and also to delays in payment on the part of the client. The five paintings of the Passion Cycle are on show today in the Alte Pinakothek in Munich. Through the large number of copies Rembrandt himself made, the *Deposition from the Cross* in particular—which clearly develops elements from Rubens' celebrated altar triptych for the cathedral in Antwerp (*The Descent from the Cross*,

1612–1614, Cathedral of Our Lady, Antwerp)—was widely distributed throughout Europe north of the Alps.

A successful artist and his busy home

At the height of his success, when he was in his early thirties, Rembrandt moved into the house in which he would live and work for the next twenty years. The buildings in Breestraat (in full Sint Anthonisbreestraat, today Jodenbreestraat), built in 1607 and therefore about as old as Rembrandt himself, had, at about the time that he moved to Amsterdam, been rebuilt by the famous master builder Jacob van Campen. The purchase was a bold move. After paying a deposit, Rembrandt agreed with Christoffel Thijsz. and Pieter Belten the payment of a total of 13,000 guilders over a period of five or at most six years. He could not know that this agreement would engulf him into an ever-growing mountain of debt. Admittedly, Rembrandt could in any case not have afforded the princely luxury of the residence of his artist colleague Rubens in Antwerp, but he made no attempt to limit the cost of the rebuilding and furnishing of the house on Breestraat. In addition to the main rooms and the areas for his extensive collection of art and curios, Rembrandt had one section of the building adapted specially for the teaching and accommodation of his pupils. It consisted of several rooms which could be heated with stoves so that the models and pupils would not get cold.

A visitor with sophisticated tastes would have regarded Rembrandt's home as something of a bear's den of furniture, people, and assorted household and art paraphernalia. But over the years a self-contained little world grew up there in which everything orbited around Rembrandt

as its creator and focal point. He had not just taken an easy solution in the selection of a suitable house; he had moved home several times during his first years in Amsterdam. The reason was not only his constantly growing family, but also his need to find space both for his own use as a studio and also for teaching and housing his pupils.

The annual fees paid by the apprentices and pupils who came to him to learn the trades of painting and printmaking formed one of Rembrandt's main sources of income. Not only contemporary sources are evidence of this; numerous sheets of drawings with the corrections by the master have survived, and they show that sometimes just a single line or a little retouching could transform a simple practice piece into a small masterpiece. The teaching was carefully organized. The pupils had no studios of their own; as drawings show, they had to share a crowded communal space. Rembrandt, who cultivated what was for the time a very cordial attitude towards his pupils, allowed the best of them to make prints from his paintings. Above all, however, his pupils had at their disposal a wide-ranging collection of both artworks and objects they could study and draw. Over the years, this art collection and cabinet of curiosities became a real attraction for upper-class travelers visiting Amsterdam.

In the decade between 1635 and 1645 there emerged from Rembrandt's studio a whole generation of Dutch artists. The fact that some of them copied the style of their master in all particulars resulted for many years in uncertainty regarding the authenticity of many famous works attributed to Rembrandt. Only in recent years has it been possible—within the framework of the preparations for the Rembrandt Jubilee year 2006, and through the parallel research programs of specialists working on the international Rembrandt Research Project—to clarify the catalogue of works which can with certainty be ascribed to the artist.

The "Night Watch" which isn't

The painting now universally known as *The Night Watch* is probably Rembrandt's most famous work, and also a key work of Dutch painting and the Baroque. With its gleaming islands of intense light and color, its vividly dramatized figures, and its dynamic complexity of composition, this large-format oil painting—commissioned in 1640 and finished in 1642—marks the high-point of Rembrandt's oeuvre.

It was also produced at a turning point in Rembrandt's life. His son Titus was born in 1641, and less than a year later his wife Saskia died; she had never fully recovered from the exertions of his birth. The family tragedy marked the beginning of Rembrandt's unstoppable descent into poverty.

That the scene shown in *The Night Watch* actually took place by day is confirmed by a watercolor drawing which Captain Frans Banningh Cocq, the most important protagonist in, and main client for, the painting, commissioned after Rembrandt's painting for his family album. This drawing, which today is also preserved in the Rijksmuseum in Amsterdam, bears the title "Sketch of the painting in the great hall of the Cloveniersdoelen, on which the young Heer van Purmerlandt [Banning Cocq] as Captain orders his lieutenant, Heer van Vlaerdingen [Willem van Ruytenburgh], to have his civilian militia company march out." The civilian militias dated back to

the wars of independence against the Spanish, but by Rembrandt's time they had lost their military and police functions. The Republic of the United Netherlands was still at war against major foreign powers, especially England, but the fighting now took place entirely at sea, so that the civilian militia companies played a role only as supporters of social life, as models for the ideals of good order and action for the common good.

From the watercolor drawing, which was produced a few years after the original, it is evident that the latter was subsequently cropped on all four sides, but especially along the top and down the left-hand edge, where a considerable portion of the painting was cut away when it was moved from the Ceremonial Hall of the Cloveniersdoelen (Musketeers' Hall), for which it had been painted, to the New Town Hall in 1715. With *The Anatomy Lesson of Dr. Nicolaes Tulp* (1632, Mauritshuis, The Hague), commissioned by the Amsterdam Guild of Surgeons, Rembrandt had already responded to the challenge of the group portrait, although its dimensions and the number of people involved made this earlier work a much more modest one. Neither that picture nor *The Night Watch* dealt with a completely new subject; both belong to the tradition of the group portrait as it was practiced in the Netherlands, in particular by Frans Hals. As in the case of *The Anatomy Lesson of Dr. Nicolaes Tulp*, in *The Night Watch* Rembrandt consciously took up the tradition, but also clearly stepped beyond the bounds of convention by depicting an animated scene into which the viewer is drawn irresistibly. Instead of a static row of portraits he created a "story" that is filled with what Leonardo da Vinci called the "movement of the soul." In

fact Rembrandt's drawings and etchings from this period reveal that his study of Leonardo's *Last Supper* played an important role in his search for a dramatic picture composition full of movement in which the event portrayed, the artistic expression, and the emotion conveyed by the figures are convincingly fused to form a whole. More than ten years after Rembrandt's death, one of his pupils, the painter Samuel van Hoogstraaten, defended the work in the face of the mounting criticism from academically focused art critics: "Whatever the objections may be, his work will outlive all those who attempt to equal him, being so painterly in conception, so dramatic in composition, and so powerful that in the opinion of some, all the other pieces in the hall stand beside it like playing cards. Still, I would have preferred him to put more light into it."

The New Town Hall: symbol of a golden age

Until the middle of the 17th century, the City Council of Amsterdam met in an old Gothic building which had been extended several times. This town hall, with a whalebone hanging from the entrance hall, was the symbol of a hard-working and inflexible mercantile city that was very attached of its traditions. But with the city's steadily increasing prosperity, which had made it one of the wealthiest in Europe, the Old Town Hall gradually lost its power as a representative building.

In 1648, after the signing of the Peace of Westphalia, which brought to an end of the decades-long wars of independence against Spain, the foundation stone was laid on Damplatz for the New Town Hall (today the Royal Palace). It was to give architectural expression to the

pride, independence, and modernity of Amsterdam. The plans for the classical-style building were the work of Jacob van Campen, who around twenty years previously, as one of his first building projects, had supervised the extension of the house in Breestraat which Rembrandt would later take over.

When van Campen's wooden model was presented it was greeted with great enthusiasm. The mayor particularly liked the tall, slender drum with its elegant dome that crowns a building that is otherwise characterized by severely classical lines. For its supporters, the new building breathed the spirit of the consuls of Ancient Rome; the architectural language was international and dispensed entirely with any references to local building traditions. Van Campen was able to realize his plans without any restrictions regarding the costs of the building. First of all he ordered the demolition of several buildings on the Dam, the inner-city district created by the canalization of the River Amstel, in order to create a fitting stage for the seat of the city government. For the pile foundations of the New Town Hall alone, 13,600 wooden posts were rammed into ground that had been gained through the construction of the canals. A convenient fire helped to speed up construction: on 9 July 1652 the Old Town Hall went up in flames. Rembrandt recorded the smoking ruins in a drawing, as if he wanted to bid his last farewell to the vanished symbol of an age which was now past.

The New Town Hall exceeded everything that had been seen or even heard of in the Netherlands up to that point. Compared with the Amsterdam project, even the royal court in The Hague, which was housed in a venerable but very cramped brick building, had every reason to be envious. What the self-assured citizens of Amsterdam wanted was a sort of Versailles on the Amstel, built according to the rules and in the proportions decreed by Palladianism, as it was taught in the architecture manuals of the 16th century. It was a building with enormous symbolic value that was to compete with the tomb of William the Silent as a political memorial to a free and independent Netherlands, and in whose gleaming marble halls the light of the Golden Age would be reflected.

The building work came to an end in 1655, as Rembrandt was moving ever faster towards bankruptcy. The painters of city views were falling over each other to depict the brand-new palace from every imaginable angle. The inauguration ceremonies were correspondingly magnificent, but were held against a backdrop of more or less bare walls. Only after that did work start on the decoration of the vast building—a field day for the local painters, sculptors, carpenters, and decorators.

The model for the new building was the interior of the Doge's Palace in Venice, where the walls and ceilings, covered with paintings by celebrated Venetian artists, proclaimed the fame of La Serenissima. The historical paintings for the palace of the citizens of Amsterdam followed a widely ranging program that extended from the deeds of the Batavi, the ancient Germanic tribe who were seen as the ancestors of the Dutch, to scenes from the Old Testament. They aimed to portray the virtues on which the success and liberty of the body politic were based: piety, justice, modesty, patriotism, steadfastness in times of trouble, pity for the poor, and so on. The most famous poets and scholars of the city drew up the plans

for the pictures, and a small but experienced team of artists was charged with their execution. The result was a pictorial atlas of Dutch history in the style of the representative historical painting of the time. Rembrandt's dark and mysterious painting style, with its sketch-like brushwork and dense application of paint, was far removed from this clearly read public style. Few thought Rembrandt, with his somber, highly personal art that refused to follow any fashion, was well suited to a public commission of this nature. The one work that was commissioned from him, *The Conspiracy of Claudius Civilis* (Nationalmuseum, Stockholm), the largest work he ever painted, was returned to him after hanging only briefly in the New Town Hall.

The task was entrusted to the representatives and imitators of a classicism which had been foreign to the Netherlands up to this point. Rembrandt knew them all. Some of them were his former pupils: Govaert Flinck (the main figure) and Ferdinand Bol; Jan Lievens, with whom he had shared a studio in Leiden; as well as some mediocre painters such as Nicolaes van Helft Stockade and Jan van Bronckhorst. In order to give the affair an international accent, the elderly Jacob Jordaens would later be invited from Antwerp; though Antwerp was no longer of political significance, its close association with the great Peter Paul Rubens gave it a cultural standing Amsterdam was keen to share. The fees paid were considerable. Up to 1,500 guilders, the annual salary of a university rector, was paid for a painting. At no point in his life did Rembrandt earn comparable sums for his paintings, with the exception of *The Night Watch*. Though he was particularly businesslike about their marketing, by far the most expensive of Rembrandt's prints was the one with the evocative name of the *Hundred Guilder Print*. And even for an exceptional painting like *Aristotle with a Bust of Homer*, he was paid only 500 guilders by the wealthy Sicilian collector Antonio Ruffo in 1654.

Anatomy of a collection: the property inventory of 1656

There are numerous archive documents relating to Rembrandt's life, though only seven written items in the artist's own hand have survived—these are Rembrandt's letters to Constantijn Huygens, which, because they deal almost exclusively with the commission for the Passion Cycle, reveal very little about the artist's private life. By contrast, an exceptionally informative document exists in the form of the inventory of property which court officials produced dated 25 and 26 July 1656 on the occasion of the bankruptcy proceedings before the forced sale of Rembrandt's household effects. As a result of this inventory, we have very precise information regarding not only his extensive collection of art but also the everyday objects of his domestic and artistic life.

The bankruptcy court entrusted a certain Henricus Torquinius with the task of compiling the list; he was assisted by two bookkeepers. The inventory was carried out room by room and began in the entrance hall. The first item lists: "A small painting by Ad[riaen] Brouwer, representing a pastry cook." The clerks continued their task without speaking, with a grim expression on their faces, dressed in gloomy black clothes despite the summer temperatures. Their pens scratched on the paper; ink dripped on the floor. Rembrandt took refuge in a steely silence, standing with a broad stance in the corridor of

the house which would soon no longer belong to him. Just occasionally he confirmed his ownership of objects and pictures that he shared with third parties, an apparently dispassionate expression in his face. Hendrickje, clever and astute as she was, had filled an entire cupboard with things and defended it as her personal property. Rembrandt's children, little Cornelia, who was just nineteen months old, but especially Titus, who was almost fifteen years old, were witnesses to the events—too young to fully understand but too old not to notice.

One of the last rooms to be dealt with was the anteroom to Rembrandt's art gallery and cabinet of curiosities, the holy of holies of his collection. It contained very special treasures. In addition to the furnishings there were a number of small but interesting pieces, including statuettes by Adam van Vianne, as well as seven paintings by Rembrandt himself and works by Hercules Seghers and Frans Hals. Item no. 298 was listed as "Three little dogs done from life," the painter being given as "Titus van Rijn," Rembrandt's son, who was also credited with book illustrations (no. 299) and a "Head of the Virgin" (no. 300). What could the drawings and little pictures of a fourteen-year-old boy be worth amid a whole flood of master drawings and paintings by Titian, Raphael, Michelangelo, Albrecht Dürer, Lucas Cranach, Hans Holbein, and Lucas van Leiden? The bookkeepers were clearly led astray by the fact that Rembrandt evidently valued his son's drawing exercises so highly that he hung them beside his own works. But Titus would not become a painter; it was only for his father that his pictures were valuable.

After two days the court officials found themselves in the last room in Rembrandt's house, the dressing room.

The official who was recording everything noted: "359: Three men's shirts; 360: Six handkerchiefs; 361: Twelve napkins; 362: Three tablecloths; 363: Several collars and cuffs." That was it. He sprinkled sand on the ink to dry it and closed his ledger. The inventory for the forced sale was complete.

Or that should have been it. Upon closer examination, however, it became evident that from a certain point onwards the entries were no longer made with the necessary thoroughness. Inconsistencies are noticeable: bureaucratically precise entries which listed every item with pedantic accuracy alternated with hurriedly scribbled general descriptions. Sometimes dozens of items were grouped together, as for example in the painting room, where the contents were catalogued by the shelf. The result was an auction list in which the individual lots were grossly undervalued. And so, far below value, the artist's possessions came under the hammer.

Rembrandt as the victim of a deception

Several months passed between the preparation of the list of possessions in July 1656 and the first auction date. First of all the bankruptcy court had to draw up a list of claimants. At the top of the list was the name of Cornelis Witsen, an important man in Amsterdam, who soon afterwards would become the city's mayor for a second time. Witsen and Christoffel Thijsz., one of the owners of the house in Breestraat, which Rembrandt had never managed to pay off in full and which proved to be his financial ruin, put pressure on the court to process the bankruptcy as quickly as possible so that

the first date for the forced sale could take place in December.

The sale was to be held in the Keizerskroon tavern, and the auctioneer was Thomas Jacobsz. Haeringh, a man with considerable experience in such matters. Rembrandt knew Haeringh well; a few years previously he had etched a portrait of his son for him to commemorate the latter's matriculation. Rembrandt had reason to hope that Haeringh would bear the artist's reputation in mind during the auction.

The date was announced on public notices throughout Amsterdam—thereby publicizing Rembrandt's bankruptcy. The local art dealers, on the other hand, kept the news secret from foreign collectors as far as possible. At first only pieces from Rembrandt's art collection came under the hammer; it contained the paintings of numerous old and newer Netherlandish and Italian masters, as well as a large number of his own works. The art dealers and agents who were present began making deals among themselves. One of the most important among them, Johannes de Renialme, who for years had bought every Rembrandt he could lay his hands on, estimated the value of the eleven works by the artist which he owned at a total of 2,000 guilders and valued a twelfth Rembrandt, *The Woman Taken in Adultery*, at no less than 1,000 guilders. In view of the large number and excellent quality of the lots available for auction, it would have been reasonable to expect that the sale would produce a large amount of money. But it turned out differently.

With every painting sold the expected total revenue was further reduced; nobody made appropriate bids, and Rembrandt found himself the victim of a deception. Even if we take into account the unusual situation under which the works were brought to auction, it remains incomprehensible how the sale of fifty of his pictures achieved a total amount of less than 1,000 guilders. Rembrandt knew very well that an estimate of his fortune demanded by his creditors in 1650 listed the value of just the pictures he had painted at 6,400 guilders. The same thing happened with the paintings by others in his collection, without doubt the most valuable group of items on the list; they, too, were assigned to the bidders at giveaway prices. After the costs had been deducted, Rembrandt was left with 1,322 guilders and 15 stuivers. A fraction of the goods' real value.

The continuation of this farce took place on 13 February, the date of the second auction. This time it was Rembrandt's house in Breestraat which was being auctioned. The first to raise their hands were a bricklayer and a nailer—stooges sent to keep the affair going and to check the offers. After being called for the third time, Rembrandt's house went to two men who were brothers-in-law; one was a shoemaker and the other a haberdasher who dealt in trimmings and silk fabrics. They offered 11,218 guilders, almost 2,000 guilders less than Rembrandt had agreed as the purchase price nineteen years previously. What is more, the payment was to be made in installments. On 22 February, the court bookkeeper summoned Rembrandt to give him the first 4,180 guilders. He was accompanied by Cornelis Witten, who as main creditor demanded the sum be handed over to him.

In September 1658, the third auction date was again publicized by issuing public notices: "The official receiv-

er, commissioned by Rembrandt van Rijn, artist, announces with the permission of the local commissioner of debts the enforced sale of the artworks included in his possession, consisting of pictures of many of the most outstanding Italian, French, German, and Dutch masters, which the said Rembrandt van Rijn has assembled personally. The sale will take place at the hour, day and year as announced, in the house of Barent Jansz. Schuurman, the landlord of the Keizerskroon tavern in Kalverstraat, where the previous auction was also held." It is not clear from the wording of the notice exactly which "artworks" would be auctioned by Haeringh on 24 September. In fact it concerned Rembrandt's impressively comprehensive collection of etchings, engravings and drawings, which he had assembled over many years and arranged according to subject. It included all the great names of the Italian Renaissance and European Baroque. Apart from all Rembrandt's etchings it included sheets by Andrea Mantegna and Raphael (summarily described as being "very valuable"), Dürer, Holbein, Hendrik Goltzius, Martin Schongauer, Bruegel the Elder, and other Old Masters. There were also works after Titian, Peter Paul Rubens, Anthony van Dyck, erotic engravings by Annibale Carracci and Rosso Fiorentino, and even some Indian book illustrations which were catalogued as "Turkish."

As could have been predicted, the auction of the prints went no differently from that of the paintings; the art dealers and collectors present made sure of that. In the end the amount raised from the auction of one of the most valuable and comprehensive print collections in private hands in Europe at that time was the miserable sum of just 600 guilders. It was out of the question that the total of 20,000 guilders determined in advance would be achieved—the sum which would have cleared Rembrandt of his debts.

Guercino's assessment

The collector Antonio Ruffo, who lived in Messina, was the first Italian to collect works by Rembrandt. The first item in his collection was the painting *Aristotle with a Bust of Homer* (1653, The Metropolitan Museum of Art, New York), which had been sent to him from Amsterdam and which is now one of the treasures of the Metropolitan Museum of Art in New York. Before purchasing further works by Rembrandt, he searched Italy—possibly in order to reduce the price a little—for artists whose style would match that of Rembrandt's *Aristotle*. Having rejected numerous candidates, including Mattia Preti, Salvator Rosa, and Giacinto Brandi, all highly esteemed artists of their time, the Sicilian nobleman finally decided to write to the artist Guercino (Giovanni Francesco Barbieri) in Bologna. It was not a bad choice, for in his early career Guercino's use of chiaroscuro could certainly stand comparison with Rembrandt's dramatic use of light and shade. However, during the later years his style had become diluted and tended increasingly towards an anemic classicism. Just like Rembrandt, Guercino was also an excellent draftsman and for this very reason the right man to paint a work that would match Rembrandt's painting, and also to provide an expert opinion on the qualities of the latter as an artist. So Ruffo had a drawing of his Rembrandt painting made and sent it to Bologna, together with a

comment expressing his surprise at Rembrandt's un-usual painting style.

The answer was not long in coming. On 13 June 1660, Guercino wrote to Ruffo: "As far as the half-figure by Rembrandt which is in the possession of Your Grace is concerned, it can only be of utter perfection; I have seen prints of several of his works which have turned up here and which are very well produced, cut with great taste and made in the best manner. From them one can con-clude that his colors must also be of choice perfection, so that I in all modesty should like to describe him as a great virtuoso." Rembrandt would perhaps have been surprised to see his works characterized by expressions such as "choice perfection." But the letter is indicative that an important artist of the Italian School, purely on the basis of knowledge of some of his prints, was able to recognize Rembrandt's mastery as a painter. While many others—buyers, critics, the upper class of Amster-dam, and even former pupils who by now had adopted classicism—turned up their noses at Rembrandt's rough, imprecise style of painting, a fellow artist in Bologna looked deeper and recognized what Rembrandt had truly achieved in his art.

Rembrandt's family as models

Like most artists, Rembrandt worked with paid models. There is evidence of this in a series of very realistic draw-ings, one of which shows a half-clothed model warming herself by a stove. The description of Rembrandt's stu-dio, which was equipped with separate rooms for the master and his pupils, provides further proof. In one of his later paintings, The Death of Lucretia (1666, National Gallery of Art, Washington), we can even see the cord the model could hold on to during the long posing sessions. But just as Rembrandt frequently painted himself, so the members of his family also served as his models, either directly or indirectly. He not only painted their portraits; he also used their features for biblical or other figures in his paintings. His mother, Cornelia, crops up sev-eral times in his early works, notably as the aged prophetess Hannah, who recognizes the infant Jesus as the Messiah when he is presented in the temple in Jeru-salem. Rembrandt's father, Harmen, appears as a philosopher in Oriental dress and also as a bearded prophet. During his time in Amsterdam, it was two women in particular who played a central role in Rem-brandt's life in succession, and whom he immortalized: his wife Saskia and Hendrickje Stoffels, both of whom he portrayed in the costume of Flora, the ancient Roman goddess of spring and fertility. Both have been identified as models for other female figures in Rembrandt's oeuvre, mostly figures of ancient mythology or history such as Sophonisba (Artemisia) or Juno, whom the painter gave the voluptuous curves of Dutch women. In addition to Rembrandt's younger sister, who died at an early age, and who appears fleetingly in some of the pic-tures from the 1630s, it was Rembrandt's only son, Titus, who played an important role in both the works and emo-tional life of his father. In addition to the portraits, which always show the boy being observed unposed or wearing a disguise, it is essentially the works in which Rembrandt lent other figures the features of his beloved son that are particularly revealing. In a painting in the Frick Collection in New York we find him in the costume of a Polish knight

(1655, *The Polish Rider*), in the Gemäldegalerie in Berlin in the guise of an angel (1660, *Jacob Wrestling the Angel*), and in the Gulbenkian Museum in Lisbon he is dressed as Alexander the Great (1663, *Alexander the Great*).

A controversial but appealing hypothesis is that the adult Titus served Rembrandt as model for the male figures in two later group portraits, the so-called *Jewish Bride* (c. 1667, Rijksmuseum, Amsterdam) and the *Family Group* (c. 1667, Herzog Anton Ulrich Museum, Braunschweig).

Geertje Dircx

There is nothing new in the fact that great artists are often idealized posthumously. In spite of all the difficulties which accompanied his last years, in spite of his financial failure and the criticism leveled at his style of painting by contemporaries, the image of Rembrandt van Rijn was soon stylized after his death and he was transformed into a hero of Dutch painting. Even Rembrandt's relationship with women, especially his marriage with Saskia, was a favorite topic for exaggeration. There is no doubt that the artist possessed a great empathy for women; many of his works bear witness to this. However, his behavior towards Geertje Dircx shows him in a different light.

After Saskia's death on 14 June 1642, Rembrandt urgently needed someone to look after Titus and take care of the household. He finally chose Geertje Dircx, the young widow of a ship's bugler, to live in his house; she soon became his model and then his mistress. The relationship between the two of them, generally regarded as compromised, seemed initially to be assuming a more stable form, and Rembrandt allowed himself to be persuaded to promise to marry her and even—a mistake which he would later regret—to give her Saskia's jewelry.

Seriously ill and in the belief that she could do as she pleased with this gift, she left the jewelry in her will of 24 January 1648 to Rembrandt's son, Titus. By this time, the artist had begun a relationship with Hendrickje Stoffels, who was just twenty-two years old, some twenty years younger than Rembrandt. Geertje Dircx brought an action for breach of promise against Rembrandt, who was ordered to pay her 200 guilders a year. But when he tried to recover Saskia's jewelry, it was discovered that Geertje Dircx had pawned some of them. A protracted court case ensued, in which gossiping neighbors spoke out against the woman Rembrandt had rejected and also—inevitably—against Hendrickje Stoffels (she and Rembrandt were not married). Geertje Dircx was declared of unsound mind and sent to the house of correction in Gouda. Rembrandt paid for the transport. After six years, Geertje succeeded in 1655, with the help of her sisters and two women from her home town of Edam, in getting herself released. She died soon afterwards. Shortly before that, Rembrandt had demanded that she repay the money he had spent on sending her to Gouda. At this point he was faced with bankruptcy and was attempting to save anything that could be saved by transferring all his possession to Titus. The necessary legal deed required the appointment of a trustee for Titus, who was still a minor, but none of Rembrandt's closer relatives was prepared to take on the responsibility, so that the Orphans' Committee had to appoint an official trustee.

Anthology

I have deliberately reserved for last a noble pair of youths from Leiden. Were I to say that they alone can vie with the greatest among the superior mortals mentioned earlier, I would still be underestimating the merits of these two; were I to say that they will soon surpass them, I would merely be expressing what their astonishing beginnings have led connoisseurs to expect.

Considering their parentage, there is no stronger argument against the belief that nobility resides in the blood. Some men pride themselves solely on this point, although I recall how cleverly they were refuted by that most brilliant of Italians, Traiano Boccalini, a modern author who writes with the greatest care and clarity. In a tale about an anatomical dissection of a nobleman's corpse, he relates how the doctors, after carefully examining the veins, unanimously declared that nobility did not dwell in the blood, since in this respect the man in no way differed from a commoner or peasant. As for my two youths, one was the son of a common embroiderer, the other a miller's son, although certainly not of the same cast. Who could help but marvel that two such prodigies of talent and skill should spring up from such rustic roots? Inquiring as to their boyhood teachers, I discover men who are barely known outside the common classes. Due to their parents' modest circumstances, the boys were compelled to take teacher's whose fees were low. Were these teachers to be confronted with their pupils today, they would feel just as abashed as those who first instructed Vergil in poetry, Cicero in oratory, and Archimedes in mathematics. Let it be said, however, with due respect for everyone's feelings and without detracting from anyone ... these two owe nothing to their teachers but everything to their aptitude. Had they never received any tuition, but instead left to their own devices and suddenly been seized by the urge to paint, I am convinced that they would have risen to the same heights they have now attained. ...

They are securely contented with themselves and neither has hitherto found it important to spend a few months traveling through Italy. In such great talents there is naturally a touch of madness, which can destroy young spirits. If only someone could drive this folly from their young heads, he would truly contribute the sole element needed to perfect their art. Oh, if only they could be acquainted with Raphael and Michelangelo, how eagerly their eyes would devour the monuments of these prodigious souls. How quickly they would surpass them all, giving Italians due cause to come to their own Holland. If only these men knew that they were born to raise art to consummate heights! ... They claim to be in the bloom of their youth and wish to profit from it; they have no time to waste on foreign travel. Moreover, since these days the kings and princes north of the Alps avidly delight in and collect pictures, the best Italian paintings can be seen outside Italy. ... Truly, they are "redeeming the time," and that is their sole occupation.

Constantijn Huygens
Autobiography, 1629–31

It must be counted as almost a miracle that although the excellent Rembrandt von Rijn came from the country and was born the son of a miller, nature led him on to such a noble art that he through great diligence and

a talent from birth achieved such a high level of art. He started as a painter under the famous Lastman in Amsterdam. He lacked nothing as regards his natural character, his diligent hard work and constant practice, except that he never visited Italy and other places where it is possible to study Antiquity and the theory of art. Moreover he could read Netherlandish only with difficulty and could therefore find little assistance from books in overcoming this lack. For this reason he clung firmly to the habits once he had acquired them.

He did not hesitate to express his disagreement with the general rules of art such as anatomy, the doctrine of the proportions of the human body, and perspective, and to question the use of the study of ancient statues and the drawing skills of Raphael. He also spoke out against a good education and against the academies, which are so necessary for the profession of a painter. He gave as reason that one should follow nature alone and no other rules.

And so, depending on the requirements of the work in question, he regarded light and shade and the outlines of objects as good—even if they contradicted the rules of perspective—as long as they were in his opinion alone well executed and served their purpose.

So that the outlines lay correctly and neatly in the right place, he filled out the background with deepest black. Because he demanded of them nothing else but that they should retain the overall harmony. He was a master of this harmony and knew how to portray unadorned nature not alone but also to adorn it with natural means through color and strong highlights. He did this especially in half-length figures, heads of old people and even in little things such as richly ornate clothing and other attractive touches. He also made engravings of very varied motifs and printed and sold them himself. All this shows that he was a very diligent and untiring man, which is why Fate granted him large sums of money and filled his house in Amsterdam with countless well-to-do pupils, who lived there for instruction and apprenticeship. Each of them paid him some 100 guilders annually as his apprentice's due—not counting the profit he made on the paintings and prints which he produced with their help, and which amounted to 2,000 to 2,500 guilders, in addition to what he earned through the work he carried out with his own hands. If he had understood better how to deal with people and had organized his affairs prudently, he could certainly have increased his wealth considerably. But although he was not a spendthrift he was not able to maintain his position and he always socialized with low people, which prevented him from working.

It was a blessing that he knew how to mix colors very cleverly and artistically according to their texture and then to use them to create on the panel the true and lively simplicity of nature, as it was seen in life. In this way he opened the eyes of all those who are more colorists than painters, as is commonly the case, in that they place the harshness and roughness of the colors mindlessly and harshly next to each other, so that they bear no resemblance to nature, but at most resemble boxes of the kind you can buy in the general store, or cloths which have been collected from the dyer's.

He was also a great lover of artworks of all kinds: paintings, drawings, copper engravings and all sorts of

foreign curiosities, of which he possessed a large number and for which he cherished a great curiosity. He was highly estimated and prized by many because of this collection.

In his works our artist showed very little light except for the place which was especially important. There he collected light and shade and also a carefully determined measure of reflection so that the light most precisely gave way to the shadow. His colors were glowing, and in all things reason prevailed.

In the representation of old people and their skin he was most diligent, patient and experienced, so that they appear very close to real life.

He seldom painted subjects from ancient poetry, allegories or complicated histories, but rather mostly simple objects which required no particular reflection, but which appealed to him ... which were nonetheless full of attractive details taken from nature.

He died in Amsterdam left a son who also apparently understands something of art.

Joachim von Sandrart
Teutsche Akademie, 1675–1680

Nature's gifts are best rewarded in the way in which they are cultivated, and the example of Rembrandt is a clear proof of the power which habit and upbringing possess over the natural talents of Man. This artist was born with a remarkable genius and a constant spirit; his temperament was productive, his thoughts subtle and unique, his pictures expressive, and his inspiration very lively. But he had imbibed with his mother's milk the taste of his country and he grew up with the constant

sight of a ponderous disposition, and since he learned too late a more perfect truth than the one that he had practiced daily, his works turned towards the aspect of that to which he was accustomed, although such good and gifted seeds had been sown in his spirit. And so you will find Raphael's taste in Rembrandt no more than you will find that of the masters of antiquity; nor will you find poetic thoughts or elegant lines. In him there is only the temperament of his homeland, absorbed by him in a lively imagination, which he is capable of bringing forth ... It is true that Rembrandt's talent in dealing with Nature made no targeted choice, but he possessed an extraordinary skill in portraying things as they are, as we can see from the various likenesses he painted. Far from being reluctant to face the comparison with another painter, in their presence they outshine those of the greatest masters.

Roger de Piles
The Art of Painting and the Lives of the Painters, 1699

When Rembrandt represents his Madonna and Child as a Dutch peasant woman, it is easy for every educated gentleman to see that this is historically inaccurate, since ... Christ was born in Bethlehem of Judaea. The Italians did it better! they say. How? Did Raphael paint anything other ... than a loving mother with her firstborn and only son? And what else could he have done? Has not mother-love in its joys and sorrows been a fanciful subject for poets and painters in all ages? But all the Bible stories been deprived of their simplicity and truth by cold grandeur and stiff ecclesiastical propriety, and have thus been taken away from sympathetic hearts in order to dazzle the gaping eyes in the stupid. Does Mary

not sit between scrolls in every altarpiece, before shepherds, as if she were displaying her Child for money, or as if she had rested for a few weeks after her confinement so as to prepare with the vanity of a fine lady for the honor of this visit? That's decent! That's proper! That does not fly in the face of history!

How does Rembrandt treat this subject? He places us in a dark stable; necessity has driven the Mother, the Child at her breast, to share a bed with the cattle.

Johann Wolfgang von Goethe
Nach Falkonet und über Falkonet, 1775

An understanding interpreter of the mature art of Rembrandt in his own day would have faced the difficult task of proving that here also a philosophy was implied—one which could compete with that of classicism but called for a very different artistic form. This philosophy put truth before beauty. But it was not only the obvious, visual truth of the physical world, but also, penetrating and conditioning it, the spiritual truth which had its roots in the Bible. Rembrandt dealt with man and nature. Both, in his conception, remain dependent upon the Supreme Force that brought them into being. Hence, even his landscapes are not self-sufficient pieces of nature separated from their source and reposing in their own beauty, as, for example, the classic *View of Delft* by Jan Vermeer. They are tied up with the creative process of all earthly life and subject to dynamic changes. There is no such thing, for him, as *nature morte*. Dead peacocks are combined in his still-life paintings with living persons. Rembrandt is unwilling to cut off anything from the continuous stream of creation—even a carcass, as we have seen in his *Slaughtered Ox*. ... Rembrandt's people, wrapped in their own thoughts, are in communication, not with the outside world, like those of Rubens, Van Dyck, or Frans Hals, but with something within themselves that leads, at the same time, beyond themselves. ... Man, so to speak, contemplates his state of dependence and accepts it in humility. Nature also is in this same state of dependence, but without knowing it. This puts man in a higher position, and makes him the most worthy subject of the painter. Rembrandt agrees here with Pascal's "toute notre dignité consiste en la pensée".

Jakob Rosenberg
Rembrandt: Life and Works, 1948

Except for Titus—who was his son—smiling, not one of his faces is serene. All seem burdened by a drama, laden. Nearly always, the figures, in their grouped and concentrated attitudes, suggest a moment's respite during a storm. They bear a heavy destiny, which they assess precisely, and which ... they will pursue to its end. Rembrandt's own drama seems to be no other than his observation of the world. He wants to know what it is all about in order to free himself. All his figures carry around a wound, and seek relief from it. Rembrandt knows he is wounded but wants to be cured. Hence the impression of vulnerability when he look at his self-portraits ... Except for a few swashbuckling portraits, all, from his earliest youth, reveal a troubled spirit in pursuit of a truth that eludes him. The sharpness of his eye is not wholly explained by a compulsion to stare hard in the mirror. At times he even

has an air of wickedness (remember that he paid to have a creditor put in prison!), of vanity (the arrogance of the ostrich plume on the velvet hat …), but little by little the hardness of the countenance softened. In front of the mirror the narcissistic satisfaction turned to anxiety and an impassioned, then tremulous, quest.

For some time he lived with Hendrickje, and this wonderful woman (those of Titus apart, only Hendrickje's portraits seem fashioned of tenderness itself and the application of the marvelous old bear) must have satisfied both his sensuality and his need for tenderness. In his last self-portraits we no longer read psychological signs. If one cares to, one can see there the advent of something like an air of goodness. Or is it detachment? Whatever one pleases. Here it come to the same thing.

Jean Genet
The Secrets of Rembrandt, 1958

It is sometimes said that the character of Rembrandt as the rebel artist is an invention of romanticism; and it is true that during the nineteenth century the Rembrandt legend, especially the story of his fall from popularity and social ostracism, was given dramatic colouring. But that the young man from Leyden saw himself as a tough and rebellious character is perfectly clear to us in a whole series of self-portraits. … This angry impatience with convention was a fundamental part of Rembrandt's character, and although he managed to control it during his years of prosperity, it came out strongly in his middle years … But side by side with this rebelliousness was an immense seriousness; nor should we be right in thinking that the young rough-neck was an uneducated boor.

Kenneth Clark
Rembrandt and the Italian Renaissance, 1966

Freedom is the keynote of Rembrandt's relationship not only to the classical ideal but to other styles and traditions as well. What has just been said about the Antique and the theory of ideal art could also be applied his artistic relationships with Dürer, Leonardo and Titian (who is perhaps the artist with whom his affinity is closest, although the resemblances between his late work and that of the Venetian may be due to coincidence). Moving nearer to Rembrandt's own country and time, there are similar analogies to be found with the work of Elsheimer, Rubens and Seghers. Rembrandt's use of all these, and other, sources, was selective and flexible. We have seen one example of the way in which his flexibility showed itself: his treatment of the classical nude. But his freedom of approach had many more consequences than this. He could paint 'high' subject-matter in a 'low' style (thus breaking the classical rule of decorum). He could combine the beautiful and the ugly, the majestic and the ordinary and, most important of all, the supernatural and the real. While accepting the obligation enjoined by classical art-theory to represent emotion in his figures, he succeeded in evolving a new, naturalistic method of doing it. It was a method quite different from that originally devised by the Italian Renaissance artists, which elsewhere in Europe during his lifetime was hardening into a formula. … Rembrandt's method was in effect no method, but an apparently di-

rect depiction of the feelings experienced by a figure, a result which he achieved as much by relying on the surrounding context and by means of the chiaroscuro and brushwork as by using movements of the facial muscles or gestures with the hand.

Michael Kitson
Rembrandt, 1969

Without hesitating, Rembrandt appropriates from those whom he admires for their style what he needs to achieve his aims. By moving closer to the scene he positions the focal point of the action in the foreground rather than the middle ground, as was also Lastman's habit ... These characteristics are also to be seen in the later work of Rembrandt, who never ceased to study the paintings of Lastman and Titian, as well as antique sculpture. A typically un-Italian feature of Rembrandt's work is his concept of space, in which he makes a conscious decision not to follow Italian examples. In Italian painting and the art theory that derives from it, picture composition plays an important part. In Italy, the imaginary space suggested by the representation had to be depicted in a perspectivally accurate and unambiguous manner. Rembrandt, in contrast, purposely makes it unclear, undefined and impossible to reconstruct. He wants to draw attention to the nature of the action, regarding the perspectival representation of space to be of secondary importance, if not dispensable. The spatial impression in Rembrandt's work is created by the dark figures in the foreground, which have the appearance of scenery one might find in on a stage.

Jaap Bolten and Henriette Bolten-Rempt
Rembrandt, 1977

Modern painters have stood in front of *The Jewish Bride* raptly dumbfounded by its prophetic invention, as if a new world of painting is unfurled on its roughly woven canvas—a world in which paint, as much as the subject, constitutes the composition; in which the paint seems to have been inseminated with virility. In 1885 Vincent van Gogh, who as a child liked to go for walks looking at the world with his eyes half-shut, sat in front of the picture in the Rijksmuseum transfixed by its mesmerizing spell. "I should be happy to give ten years of my life," he told his friend Kersemakers, with whom he was visiting the museum, "if I could go on sitting in front of this picture for ten days with only a dry crust of bread."... In the most prestigious passages of his last paintings, Rembrandt was indeed creating a kind of work that went realms beyond the most radical and broken inventions of Titian and even the startling patch-and-daub painting of Velázquez. In both these cases, and in his own earlier work, the loose or rough brushwork was meant to resolve itself at the right distance into a cohering form. But in the heat of his urgent old age, Rembrandt was actually playing with paint in ways that precluded such resolution; that failed to describe anything but itself.

Simon Schama
Rembrandt's Eye, 2000

Locations

AUSTRIA
Vienna
Kunsthistorisches Museum
Self-Portrait, 1652
Titus Reading, c. 1657

BRITAIN
Edinburgh
National Gallery of Scotland
A Woman in Bed, 1645
London
Kenwood House, The Iveagh Bequest
Self-Portrait with Two Circles,
c. 1663
National Gallery
Belshazzar's Feast, c. 1635
Saskia as Flora, 1635
*Self-Portrait at the Age of Thirty-
Four*, 1640
The Woman Taken in Adultery, 1644
*A Woman Bathing in a Stream (Hen-
drickje Stoffels?)*, 1654
Portrait of Jacob Trip, c. 1661

FRANCE
Lyon
Musée des Beaux-Arts

The Stoning of Saint Stephen, 1625
Paris
Musée du Louvre
The Slaughtered Ox, c. 1655

GERMANY
Berlin
Gemäldegalerie
*The Money Changer (The Parable of
the Rich Fool)*, 1627
Cornelis Anslo and His Wife, 1641
*Hendrickje Stoffels (Young Girl at
the Window)*, 1657
Jacob Wrestling the Angel, 1660
Braunschweig
Herzog Anton Ullrich Museum
Family Portrait, c. 1667
Dresden
Gemäldegalerie
Hunter with Bittern, 1639
*Self-Portrait with Saskia (or The
Prodigal Son with a Whore)*, c. 1636
Frankfurt
Städelsches Kunstinstitut
The Blinding of Samson, 1636
Kassel
Gemäldegalerie

Holy Family with a Curtain, 1645
*Jacob Blessing the Children of
Joseph*, 1656
Portrait of Johannes Bruyningh,
1657
Stuttgart
Staatsgalerie
St. Paul in Prison, 1627

THE NETHERLANDS
Amsterdam
Historical Museum
The Anatomy Lesson of Dr. Deyman,
1656
Rijksmuseum
Tobit and Hanna with a Kid, 1626
Self-Portrait at an Early Age,
c. 1627
*Jeremiah Lamenting the Destruc-
tion of Jerusalem*, 1630
*Rembrandt's Mother as the
Prophetess Hannah*, 1631
Landscape with a Stone Bridge,
1636
Dead Peacocks, c. 1638
*The Night Watch (The Company of
Frans Banning Cocq)*, 1642

Peter Denies Christ, 1661
The Sampling Officials of the
Drapers' Guild, 1662
The Jewish Bride, c. 1667
Rotterdam
Boymans van Beuningen Museum
Titus at His Desk, 1655
Six Collection
Portrait of Jan Six, 1654
The Hague
Mauritshuis
The Presentation of Jesus in the
Temple, 1631
The Anatomy Lesson of Dr. Nicolaes
Tulp, 1632
Two Africans, 1661
Self-Portrait, 1669

RUSSIA
St. Petersburg
The State Hermitage Museum
Saskia as Flora, 1634
The Sacrifice of Isaac, 1635
Danaë, 1636
David Taking Leave of Jonathan, 1642
Holy Family with Angels, 1645
The Return of the Prodigal Son, c. 1668

SPAIN
Madrid
Museo Nacional del Prado
Artemisia (Sophonisba Receiving the
Poisoned Cup), 1634

SWEDEN
Stockholm
Nationalmuseum
The Conspiracy of Claudius Civilis,
1661

USA
Boston
Museum of Fine Arts
The Artist in His Studio, 1628
New York
The Frick Collection
The Polish Rider, 1655
Self-Portrait, 1658
The Metropolitan Museum of Art
Aristotle with a Bust of Homer,
1653

Chronology

The following is a brief overview of the main events in the artist's life, plus the main historical events in his day (*in italic*).

1606
Rembrandt is born in Leiden on 15 July, the son of the miller Harmen Gerritszoon van Rijn and Cornelia (Neeltje) van Suijttbroeck, who comes from a Catholic family of bakers.

Political-denominational tensions among Dutch Calvinists.

1613–1620
Rembrandt is the only one of his parents' nine children to attend Leiden's Latin School, where he studies for seven years.

1620
Registers at Leiden University, but soon takes up an apprenticeship under the painter Jacob Isaacszoon van Swanenburgh, known for his landscapes and his representations of Hell.

Following the outbreak of the Thirty Years' War in 1618, the strict form of Calvinism is established in the Netherlands under the stadtholder Maurice of Orange.

1624
Spends six months in the studio of Pieter Lastman in Amsterdam before returning to Leiden. He and Jan Lievens open their own studio together.

Founding of the Dutch colony of New Amsterdam on the island of Manhattan.

1625
Paints *The Stoning of Saint Stephen*, his earliest extant painting.

Frederik Hendrik assumes the role of stadtholder of the Netherlands following the death of his brother, Maurice of Orange.

1628
Constantijn Huygens, an influential diplomat in the service of the House of Orange, author and art connoisseur, visits Rembrandt and Lievens in Leiden.

1630
Moves from Leiden to Amsterdam.

1631
(20 June) Negotiates an agreement with the Amsterdam art dealer Gerrit van Uylenburgh, giving him exclusive right of sale for his works.

Dutch trade extends to Brazil; the island of Ceylon (Sri Lanka) is acquired under the terms of a later contract.

1632
Receives his first commission from Amsterdam's upper classes: *The Anatomy Lesson of Dr. Nicolaes Tulp.*

1633–1634
(5 June 1633) Becomes engaged to Saskia van Uylenburgh, the art dealer's cousin, and marries her on 22 July 1634.

1635–1639
Builds up an extensive collection of art works, curios and natural objects. The money he lavishes on his collecting provokes consternation and open opposition from the relatives of Saskia, who brought a considerable dowry into the marriage.

The North Sea comes under the control of the Dutch war fleet; naval victories over the Spanish; further expansion of Dutch influence over Brazil and of the East Indies trade; Dutch presence on the coasts of Africa, North and South America.

1639
Commits himself to the payment of 13,000 guilders within six years for the purchase of a property on Breestraat, making an initial payment of only a fraction of the total. (1 May 1639) He and Saskia move into the new house.

1640
His mother dies in Leiden, and is interred on 14 September.

1641

(22 September) Titus, his only son to reach adulthood, is christened .

1642

His fame reaches its pinnacle with the completion of the so-called *Night Watch*. (14 June) Weakened by the birth of their son, his wife Saskia dies of consumption. Geertje Dircx becomes part of the household as a wet nurse, and becomes Rembrandt's mistress.

1643–1647

Unable to afford the payments due on his house, Rembrandt turns to well-situated friends, asking for their support.

1647 Frederik Henrik, Prince of Orange, dies. His son, William II, Prince of Orange, consort of Mary Henrietta of England, becomes his successor as stadtholder of the Netherlands.

1648–1650

In her will of 24 January 1648, Geertje Dircx leaves her property, including Saskia's jewelry, to Rembrandt's son Titus. In the legal dispute that follows, Rembrandt's new mistress, Hendrickje Stoffels, acts as witness against Geertje, who is finally sentenced to a period in a house of correction.

The Peace of Westphalia seals the end of the Thirty Years' War, and the recognition of the Netherlands as an independent state. The death of William II of Orange in 1650 marks the end of the office of stadtholder.

1652

In the face of increasing financial pressure, he asks his friend Jan Six, a wealthy patrician of Amsterdam, for credit. In payment, Rembrandt paints his portrait, considered one of the painter's most important works.

The negative impact on Dutch sea trade of the English crown's Act of Navigation (1651) begins to make itself felt.

1654

Hendrickje Stoffels, with whom Rembrandt cohabits, gives birth to a daughter, who is named after Rembrandt's mother, Cornelia.

1656–1658

In order to prevent the loss of his entire estate in the case of bankruptcy, Rembrandt transfers his property to his son Titus, who is still a minor. In July 1656, a legal inventory of Rembrandt's entire estate is drawn up. Rembrandt's collection and house are sold at auction on three dates, ending in February 1658.

1660

(18 December) He and his family move into a modest apartment building on Rozengracht.

1661

Paints *The Conspiracy of Claudius Civilis* for Amsterdam's New Town Hall. In 1662, the painting is taken down and returned to Rembrandt.

1663

(21 July) Hendrickje Stoffels dies of the plague.

1664–1669

During the last years of his life, Rembrandt creates a series of impressive self-portraits.

Sale of the Dutch settlements in Connecticut and Delaware. New Amsterdam is renamed New York.

1667

Titus van Rijn is engaged to Magdalena van Loo, daughter of a relative of his mother, Saskia van Uylenburgh.

1668

(10 February) Titus and Magdalena are married. (14 September) Titus dies of the plague.

1669

Titus's daughter Titia is born in March. (4 March) Rembrandt dies. He is interred in an unmarked location in Amsterdam's Westerkerk, where his family members have also been laid to rest.

Literature

Lives of Rembrandt: Sandrart, Baldinucci and Houbraken, translated by Charles Ford, London 2008

Georg Simmel, Rembrandt, 1916: translation: Rembrandt, London 2005

Henri Focillon, Rembrandt, 1936: translation: Rembrandt: Paintings, Drawings, and Etchings, New York 1960

Jakob Rosenberg, Rembrandt: Life and Work, New York 1948

Otto Benesch, Rembrandt, New York 1957

Kenneth Clark, Rembrandt and the Italian Renaissance, London 1966

Joseph-Emile Muller, Rembrandt, London 1968

Michael Kitson, Rembrandt, London 1969

Bob Haak, Rembrandt: Drawings, London 1976

Kenneth Clark, An Introduction to Rembrandt, London 1978

Christopher White, Rembrandt, New York 1984

Gary Schwartz, Rembrandt: His Life, His Paintings, London 1985

Svetlana Alpers, Rembrandt's Enterprise: The Studio and the Market, London 1988

Gary Schwartz, The Complete Etchings of Rembrandt, New York 1994

Charles L. Mee, Rembrandt's Portraits: A Biography, New York 1988

Christopher Brown and others, Rembrandt: The Master and his Workshop, New Haven and London 1991

Simon Schama, Rembrandt's Eye, London 2000

Ernst van de Wetering, Rembrandt: The Painter at Work, Amsterdam 2000

Julia Lloyd Williams, Rembrandt's Women, Munich, London and New York 2003

Clifford Ackley and others, Rembrandt's Journey, Boston 2004

David Bomford and others, Art in the Making: Rembrandt, London 2006

Paul Crenshaw, Rembrandt's Bankruptcy: The Artist, His Patrons, and the Art Market in Seventeenth-Century Netherlands, New York 2006

Giovanni Arpino (ed.), Rembrandt, New York 2007

Eric Jan Sluijter, Rembrandt and the Female Nude, Amsterdam 2007

Michael Taylor, Rembrandt's Nose: Of Flesh & Spirit in the Master's Portraits, New York 2007